Images of Modern America

INDIANA'S LOST
NATIONAL ROAD

Images of Modern America

INDIANA'S LOST NATIONAL ROAD

David Humphrey
Foreword by Dan Carpenter

ARCADIA
PUBLISHING

Published by Arcadia Publishing
Charleston, South Carolina

Printed in the United States of America

Library of Congress Control Number: 2017960617

For all general information, please contact Arcadia Publishing:
Telephone 843-853-2070
Fax 843-853-0044
E-mail sales@arcadiapublishing.com
For customer service and orders:
Toll-Free 1-888-313-2665

Visit us on the Internet at www.arcadiapublishing.com

CONTENTS

FOREWORD

By the time I started my commute from Indianapolis to Greenfield nearly a half century ago, taking on my first newspaper job, US 40 bisecting Indiana already was entering the decline that David Humphrey's book so vividly chronicles. The historic National Road that linked Richmond and Earlham College on the east to Terre Haute and Indiana State University on the west showed me shopping centers and brisk traffic, but it was visibly fading as a commercial artery and was undergoing a distinctly nontherapeutic bypass operation.

Interstate 70 was online from the east border of the state to a point about 20 miles east of Indianapolis when I started work in 1970. Within a year, the Indianapolis leg would be complete and incentive for traveling stoplight to stoplight along 40, for all but local errands, would be pretty much history. While I-70 took over for 40 in the eastern half of the nation, Interstate 80 up in northern Indiana was the usurper all the way to the West Coast. Together, 70 and 80 have long since eclipsed a corridor that traces its genesis to the early 19th century and its origin as a designated US highway to 1926, when it linked San Francisco with Atlantic City, New Jersey.

Deserts, mountains, farmland, and rural hamlets have always dominated the route in terms of sheer miles, but cities with their leafy and slum neighborhoods, their factory districts, their universities, and city halls and state capitols were indispensable pulse points in the beginning and remain so. In Indianapolis, the thoroughfare known as Washington Street drove the city's ascendancy as the address for its downtown business hub and statehouse, intersecting the other main drag, Meridian Street, at a point proudly proclaimed as "The Crossroads of America." A few miles east, distinctively designed enclaves such as Lockerbie, Irvington, and Woodruff Place housed the well-do-do.

The urban section of US 40 in Indianapolis, like its rural cousins east and west, has had its travails. Downtown and the immediate surrounding neighborhoods deteriorated starkly in the 1960s and 1970s. But unlike the more isolated stretches in the state, the city's heart has seen massive revitalization over the past several decades, reflected in sports stadiums, retail centers, dining, and condo proliferation. Neighborhoods, to a lesser but significant extent, have benefitted as well.

The host of other Hoosier cities and town where US 40 has a history as the main drag cannot claim such a rebirth. The road varies in its vitality, from Terre Haute where it has long been rerouted from downtown, to Plainfield, with extensive shopping and preservation, to small communities where only a faint pulse is shown. The bottom line for nostalgic motorists such as I: No more stops at the Eastgate Shopping Center or Paramount Music Palace or the Knife & Fork diner. They are gone from US 40, as are most of us.

—Dan Carpenter

ACKNOWLEDGMENTS

I would like to thank the people at the Hancock Public Library, Indiana Landmarks, Indiana National Road Association, Morrison-Reeves Library, Old National Road Welcome Center, Plainfield Public Library, and the Vigo County Public Library for providing me historical information on Indiana's National Road. Very special thanks go to Dan Carpenter, the gifted Indianapolis author, who graciously penned the foreword to this book. All photographs within this book are works of the author. Vintage postcards are from the author's collection.

INTRODUCTION

My father was somewhat a troubadour of the highway. I vividly remember him taking many of Indiana's celebrated state roads on our family outings. When it was time to take to the road, my siblings and I anxiously hopped into dad's Chevy Impala while he made a last-minute inspection beneath the hood. Mom, meanwhile, loaded our Coke cooler into the trunk of the car filled with iced bottled pop, Emge lunch meat, and sweet treats from the Omar Man. Before leaving our driveway, dad surveyed his Texaco road map one last time with a scrutinized eye.

In the 1960s, the interstate system was in its early stage of development. Dad scoffed at the idea of traveling on pavement that came to an abrupt end in the middle of nowhere. Even after interstates became the roads more traveled, Dad preferred the scenic state roads, a trait inherited by his son.

The state roads and highways that I traveled in my youth are far too many to remember. However, there are those that took me to special places that were a home away from home. Highway 36 was a direct drive to my grandmother's farm in Illinois. State Road 9 was the route we took to my Uncle Jim's cottage on Dewart Lake in northern Indiana. Indiana 40 took us either to Richmond or Terre Haute, but visits to those cities were few and far between. But I do remember Dad taking me to see the devastated ruins of downtown Richmond after the fatal gas explosion in the spring of 1968. It occurred only two days after Dr. Martin Luther King Jr. was murdered in Memphis, Tennessee. Those tragic events showed me how vulnerable we were to the world around us and how life could end at any given moment in time.

In the early 2000s, I was given a newspaper assignment to photograph an antique shop owner in Dublin, Indiana. Patricia McDaniel, proprietor of Old Storefront Antiques, had recently traveled the National Road and wrote a book about her travels titled *Historic National Road Yard Sale Cookbook*. On the way to McDaniel's store in Dublin, I noticed that Indiana's National Road had changed since I first traveled it when I was young. Indeed, there still were thriving small businesses along the route, including the shop owned by McDaniel. But gone were many of the hotels, restaurants, and roadside picnic areas where travelers once stopped for lunch and a place to rest. Interstate travel, national retail store chains, and fast-food restaurants had somewhat made Indiana 40 a desolated road. Rustic signs, abandoned buildings, farmhouses, and barns hidden by voluminous growth of trees have become common sites on the road that helped shape Indiana.

The rich history of Indiana's National Road dates back to 1827. It was then that Jonathon Knight surveyed the National Road across Indiana, 20 years after Thomas Jefferson's administration commissioned the National Road as the first federally funded highway. Construction on Indiana's segment of the National Road began in Indianapolis in 1828 and simultaneously expanded to the east and west. After the road was completed, it stretched from Richmond to Terre Haute, passing through Indianapolis, the state capital. The newly constructed highway brought settlers into the area and served as an important trade route. Towns founded along the route became a vital part in making Indiana's National Road a success.

In the 1830s and 1840s, however, Indiana's National Road entered a period of decline. By the 1850s, railroads took away the majority of travel. The lack of federal funding led towns, counties, and private businesses to paying for road maintenance. But all of that changed with the mass production of the automobile. In the early 1900s, the Good Roads Movement, which advocated for better road conditions nationwide, was launched. With efforts made by the Good Roads Movement, Daughters of the American Revolution, and the American Automobile Association, Congress passed the 1916 Federal Aid Highway Act. A decade later, the National Road was included in the designation of US 40.

It is common belief that Interstate 70 played a major role in the demise of Indiana's National Road, while others lay blame on commercialization or even corporate greed. Though these claims may be true, they cannot take away the fact that Indiana's National Road will forever play an integral role in understanding the rich history of the Hoosier State. When traveling through the small towns, cities, and ravishing rural landscapes of Indiana 40, it is easy to see and understand why many embrace a simpler way of life and why Indiana's National Road remains a monumental treasure.

Murals of jazz greats adorn the exterior walls of downtown Richmond buildings, honoring the celebrated musicians who recorded for Gennett Records. Founded in Richmond in 1917 by the Starr Piano Company, Gennett produced some of the earliest recordings of Louis Armstrong, Jelly Roll Morton, and Indiana's own Hoagy Carmichael. Philadelphia Church Cemetery in Hancock County is the final resting place for Mary Alice Smith Gray, the real-life subject of James Whitcomb Riley's poem "Little Orphant Annie," published in 1885. Gray was an orphan who lived in the Riley household as a child. "Little Orphant Annie" died in 1924 at the age of 73. On December 3, 1913, the Irving Theatre officially opened. Located in the center of the Irvington Historic District, the Irving has changed ownership several times through the years but has always remained a theater. Today, the Irving continues to host music, comedy, and plays on the theater stage. Seventy-six miles west of Indianapolis is the city of Terre Haute, site of the Rose-Hulman Institute of Technology and the historic Highland Lawn Cemetery. Interred at Highland Lawn is Eugene Debs, the renowned social and labor leader and member of the Socialist Party of America. From 1904 to 1920, Debs ran for president five times, conducting his last campaign while imprisoned at the Atlanta Federal Penitentiary. Debs died on October 20, 1926. Though Debs is listed as being buried in the Debs family plot, he and his wife, Kate, were laid to rest in a different section of the cemetery, upon the request of Debs's immediate family, to avoid vandalism to his headstone.

In the electronic age in which we now live, where yesterday's news is often considered ancient history, it is hard to imagine what the future holds for Indiana's National Road. Fifty years down the road, will more homes, buildings, or even towns on Indiana's National Road lie in ruins? Or will the historic road find resurrection? With the undying efforts of organizations such as the Indiana National Road Association and Indiana Landmarks, the present-day and past-day Indiana National Road will hopefully be preserved, not only for the sake of posterity but also for the sake of humankind.

One

RICHMOND TO DUNREITH

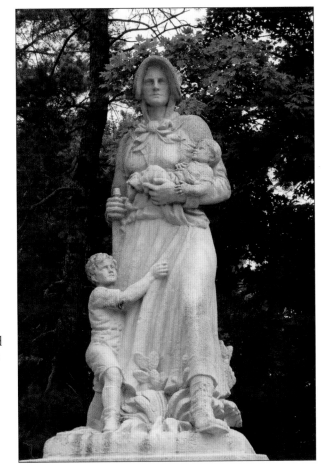

The *Madonna of the Trail* statue stands at the entrance of Glenn Miller Park in Richmond. The monument was the design of St. Louis sculptor August Leimbach. On October 25, 1918, the *Madonna of the Trail* was dedicated by the Daughters of the American Revolution. To commemorate the 75th anniversary of the monument, a state celebration was held at Glenn Miller Park on August 9, 2003. In 2005, the monument was restored to its original cherry cream color.

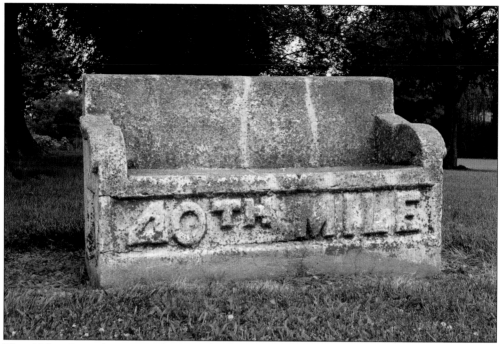

This 40th mile marker sits on the east side of Dunreith. That marker let early-day travelers know that it was 40 miles to Indianapolis and 40 miles to Richmond.

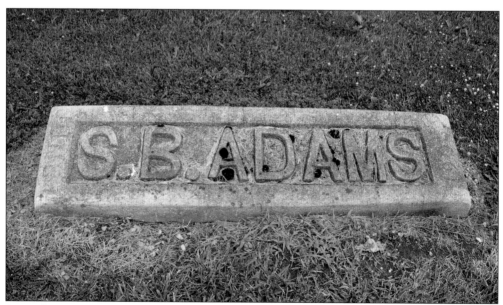

S.B. Adams was a well-known and successful businessman in the Dunreith and Lewisville areas. Adams made most of his fortune from the poultry business while he was still a young man. In 1895, Adams built a home for his daughter Argolda Adams Kiplinger just east of Dunreith on the National Road. The historic home was struck by lightning and burned to the ground in 1964. This marker, which bears the name of S.B. Adams, can be found on the property where his daughter's home once stood.

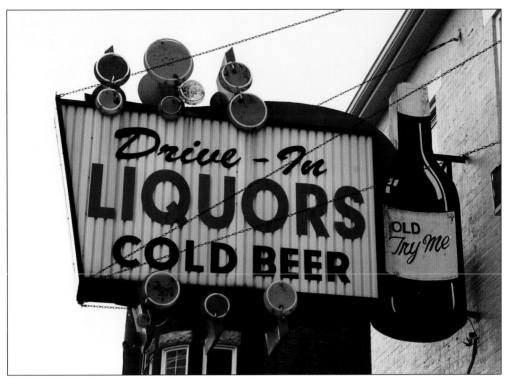

In the heart of downtown Cambridge City, amongst antique stores and eateries, is the Bob-O-Link Liquor Store. Before being renamed Bob-O-Link in 2015, the liquor store was known as Drive-In Liquors. No matter the name, the neon business signs for both liquor stores are truly unique.

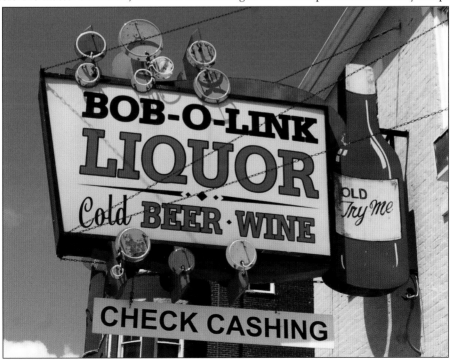

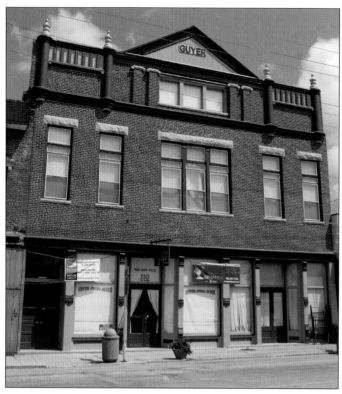

Guyer Opera House is located in the heart of Lewisville. Constructed in 1901 by O.K. Guyer, the two-story brick building is also known as Lewisville Public Hall. In 1979, the Guyer Opera House was listed in the National Register of Historic Places. Today, the community theater presents plays, concerts, operas, and musicals.

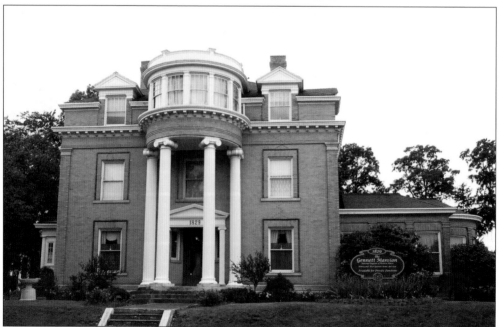

The Henry and Alice Gennett House, also known as the Gennett Mansion, is a historic home located in Richmond's Glenn Miller Park Historic District. Built in 1898, the large two-story Colonial Revival–style home was listed in the National Register of Historic Places in 1983. Henry Gennett was president of the Starr Piano Company from 1898 to 1922 and founder of Gennett Records.

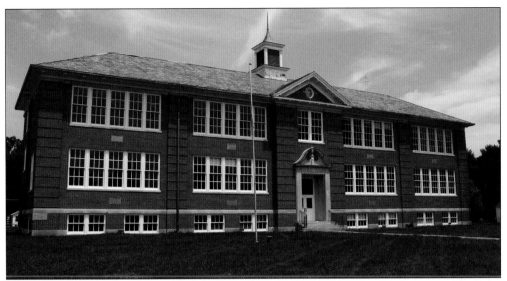

Cambridge City's Central School was built in 1935 with additions made to the facility in 1972. As in the case of many Indiana public schools, consolidation lead to the closing of Central School in the late 1990s. At one time, the elementary school was considered as a site for a library but those plans collapsed. Today, the beautifully designed Central School with its redbrick exterior remains unoccupied.

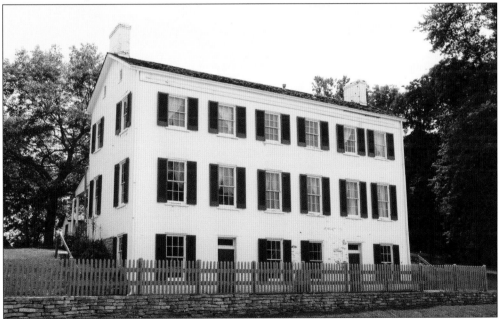

John Huddleston, his wife, Susannah, and their 11 children opened their home to travelers on the National Road, where they were offered a place to eat, rest, and lodge for the night. The Huddleston family operated their home as an inn between the years 1850 and 1875. The three-story home was purchased by Indiana Landmarks in 1966 and restored to its original beauty. In 1975, the Huddleston Farmhouse was listed in the National Register of Historic Places. Located on the outskirts of Cambridge City, the Huddleston Farmhouse now serves as the Indiana Landmarks Eastern Regional Office and office of the Indiana National Road Association.

Ma Parish operated the National Grocery and Lunch Room from this building constructed in 1880. Ma's daughter Sadie O'Melia lived in the old store before advanced age forced her to settle in a Shelbyville nursing home. The last known occupants of the now vacant building were antique dealers Bob and Correna Thompson. The building once had a front porch but it was removed in 1928 when Indiana 40 was widened.

National Trail is stenciled on the front of the old National Grocery and Lunch Room. For a brief period of time, the building was for sale but has since been taken off the market.

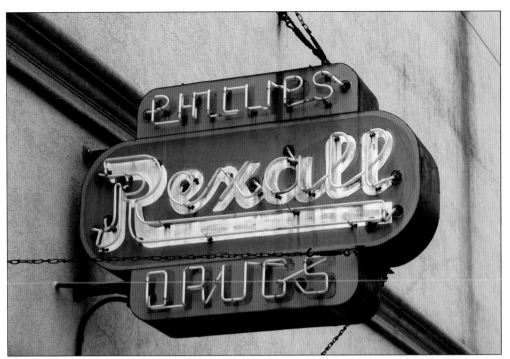

Phillips Drugs has three pharmacies in Richmond, including a location on the National Road. This vintage Phillips Rexall Drugs sign is a reminder of drugstores from yesteryear. Phillips Drugs is locally owned and has served the Richmond community for over 60 years.

A US 40 road sign is visible through the window of an abandoned building located on the eastern leg of Indiana's National Road.

Absolute Antiques is located on the corner of US 40 and Highway 103, in the heart of Lewisville. The antique and gift shop sells furniture, stained glass, clocks, books, tables, rugs, and other items of interest.

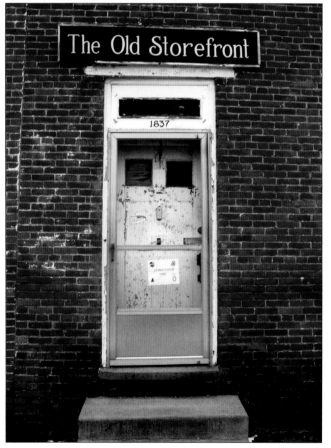

Old Storefront Antiques is owned and operated by Patricia McDaniel, who sells vintage pharmaceuticals, movie props, and advertising memorabilia. McDaniel has written cookbooks and is chairperson for the annual Historic National Road Yard Sale. In 1985, McDaniel purchased the Federal-style building, which had been constructed in 1837. It is the second-oldest building in the town of Dublin.

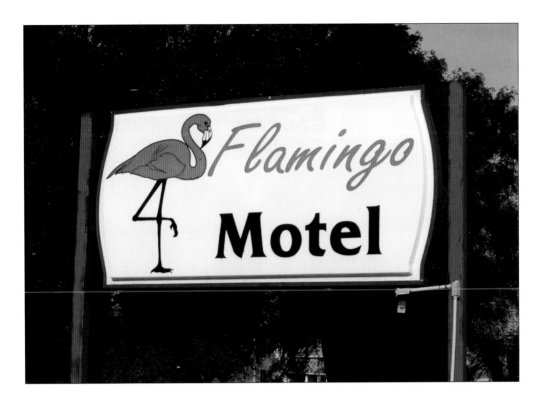

The Flamingo Motel is a reminder of days gone by for the old roadside inns. Located just off the National Road in Dunreith, this motel stands adjacent to the Flamingo Restaurant, which serves breakfast, lunch, and dinner to travelers and the townspeople of Dunreith. Standing outside the Flamingo Motel office are vintage Pepsi and Coca-Cola machines.

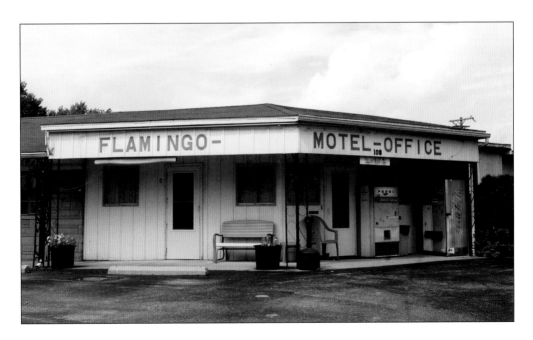

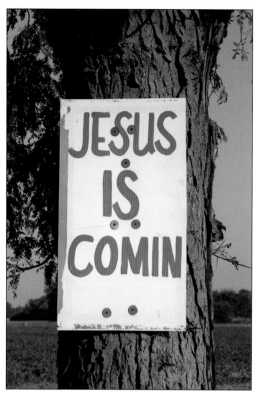

Signs promoting religion or one's belief in a creator are common sites along Indiana's National Road. At left, a hand-painted sign nailed to a tree along the eastern leg of Indiana 40 proclaims that Jesus will soon return to Earth. Below, attached to a yard light on the property of a Lewisville home, is a more formal sign stating, "Ye Must Be Born Again," a verse from the Bible.

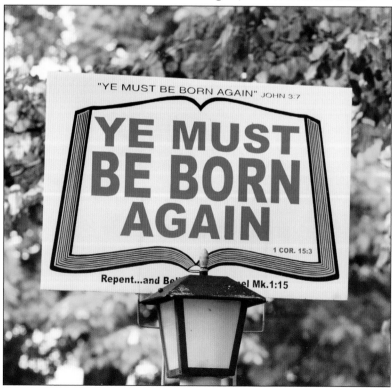

Abandoned barns along Indiana's National Road are a stark reminder of family-owned farms from yesteryear. This tin-roofed barn is located on the outskirts of Cambridge City.

A silhouetted horse and buggy grace the exterior of this modest white barn located near Cambridge City.

Standing near the entrance of a Cambridge City antique store is a lawn jockey. This particular lawn jockey is of the "cavalier spirit" style, a taller version of the shorter "jocko" design. Though many see the lawn jockey as controversial, others see the concrete statues as collectable ornaments.

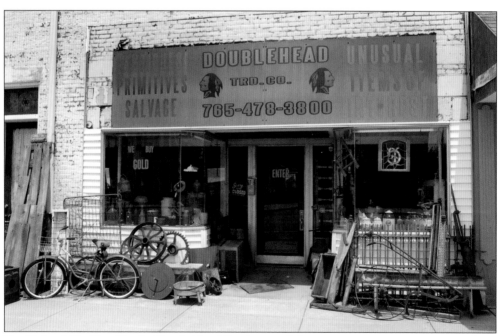

Doublehead Trading Co. in Cambridge City is one of the more unique antique stores along Indiana's National Road. With the biggest selection of bottles and jars in the state, Doublehead Trading Co. also specializes in architectural supplies, with an abundance of window frames, doors, and antique wood furniture.

Trees and shrubbery engulf this empty house just west of downtown Richmond on the National Road. At the entrance of the driveway is a rusted mailbox with the home address faded from the sun.

Behind the unoccupied house is a shed, leaning in its old age, that may have once been used for storage.

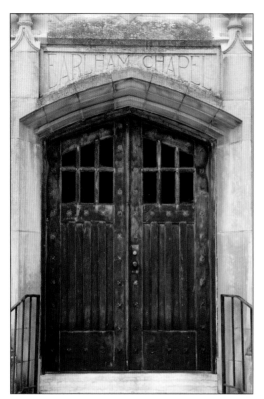

Earlham Chapel is located on the grounds of Earlham Cemetery, located just west of Richmond near Earlham College. Founded in 1861, Earlham Cemetery was incorporated in 1863. The cemetery has over 140 acres of landscaped property. As of today, there are over 38,000 interments at the cemetery. The first person buried at Earlham Cemetery was Elijah Coffin, age 62. Coffin was laid to rest on January 24, 1862.

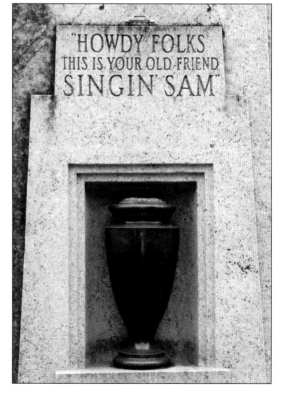

One of the more talked-about and visited monuments at Earlham Cemetery is that of Singin' Sam, also known as Harry Frankel. Singin' Sam was an early-day radio personality, minstrel performer, and vaudevillian. The performer was long associated with Barbasol and also did shows for Coca-Cola. He died in Richmond in 1948 at the age of 60.

The Stars and Stripes is perfectly framed in the window of a vacated building in Lewisville. The American flag is prevalent in distinct variations along Indiana's National Road.

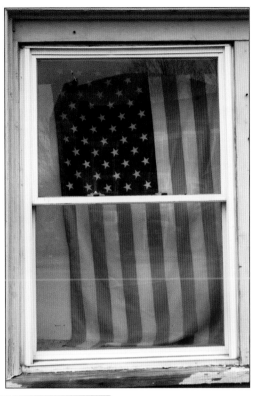

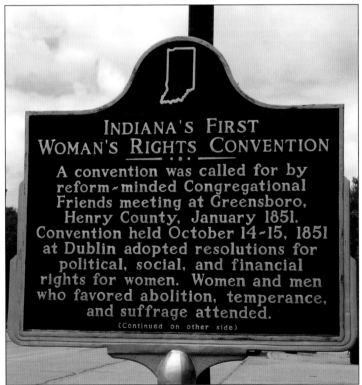

INDIANA'S FIRST WOMAN'S RIGHTS CONVENTION

A convention was called for by reform-minded Congregational Friends meeting at Greensboro, Henry County, January 1851. Convention held October 14-15, 1851 at Dublin adopted resolutions for political, social, and financial rights for women. Women and men who favored abolition, temperance, and suffrage attended.

(Continued on other side)

Indiana's First Woman's Rights Convention was held October 14–15, 1851, in Dublin. The convention adopted resolutions for social, political, and financial rights for women. One year later, the Indiana Woman's Rights Association, which further promoted women's rights, was founded. In 1870, the association voted to be auxiliary to the American Woman Suffrage Association, which later became Indiana Woman's Suffrage Association. Dedication of the historical marker took place on May 24, 2003, and it stands in the heart of Dublin.

A Closed sign is visible through the ragged screen door of a vacant building in Dunreith. Though the building has seen its better days, it once served as a post office, antique store, and grocery store. The building was erected in 1911 by John Fry.

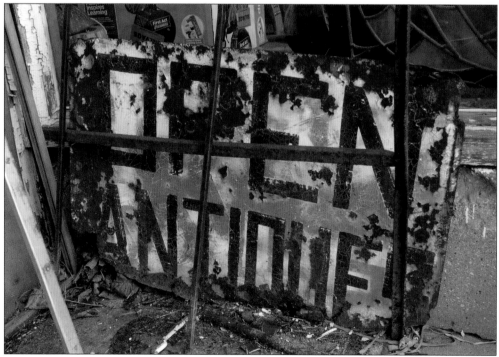

Lying in the doorway of an empty building in the town of Lewisville is a rusted "Open Antiques" sign. Corroded bicycles line the exterior wall of an additional vacated building across the street.

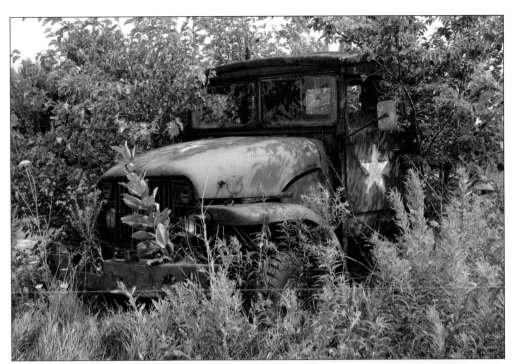

Overgrown brush and weeds all but camouflage this US Army jeep that idly sits in a field near the town of Straughn.

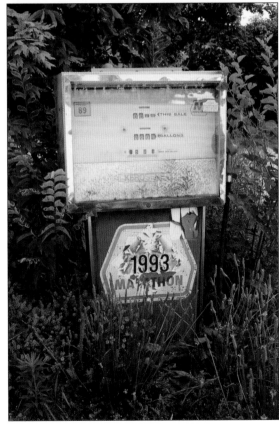

Weeds and tall grass encompass this Marathon Kerosene pump standing near a boarded-up service station on the corner of Indiana 40 and Indiana 3 in Dunreith.

A shattered sign is all that remains of a once prosperous Lewisville antique store. Located in Henry County along Flat Rock River, Lewisville is known as the "Home of the Houston Brick."

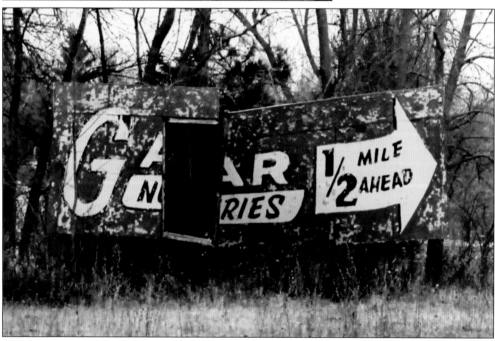

Weather-beaten and timeworn, this billboard advertisement for Gaar's Nursery in Cambridge City stands alone in a barren field.

This 1931 Chevy truck was first used by the Pendleton Fire Department and later by the Dunreith Fire Department. The Pendleton Fire Department purchased the truck in December 1937 from B and C Chevrolet for $175. Howe Fire Apparatus in Anderson modified the truck for an additional $1,267. The truck was sold to the Dunreith Fire Department on June 9, 1949. In 1973, the truck ended up in Texas and was purchased at an auction by a man who owned service stations in the Houston area. Years later, the truck found its way back to Pendleton, where money is being raised for its restoration. Note on the side door how Dunreith is painted over Pendleton.

A shattered headstone lies on a slab of cement at Dunreith Cemetery. The first burial to take place at Dunreith Cemetery was in 1834. The last marked burial took place in 1939, and the last unmarked burial occurred in the early 1960s. A total of 172 burials are recorded at the cemetery located off Indiana's National Road. Seven of those interred at the cemetery are veterans of the Civil War. On New Year's Day 1968, a train derailed from a nearby track, damaging many of the cemetery's headstones.

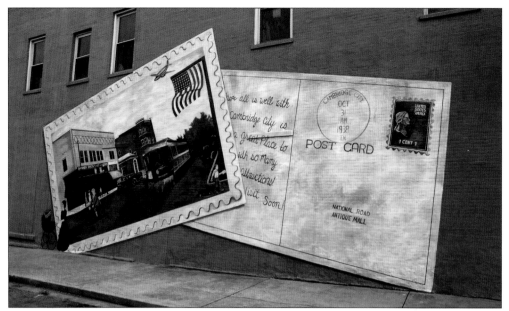

Beautiful murals decorate the exterior walls of buildings in downtown Cambridge City. This particular mural depicts a postcard from 1930s Cambridge City, with the interurban running through town. The postcard is dated October 31, 1938, complete with a 1¢ stamp.

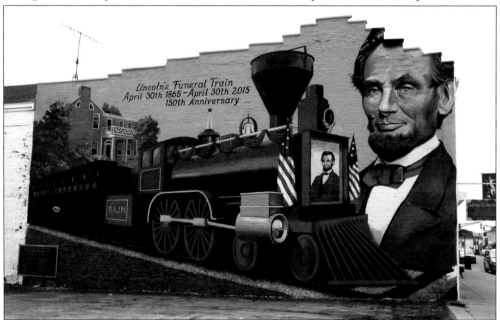

After Pres. Abraham Lincoln was assassinated in April 1865, his funeral train passed through Cambridge City. The funeral train made three stops in the town on April 30 so all of the 3,000 people lining the streets could view it. To commemorate the 150th anniversary of President Lincoln's death, buildings in downtown Cambridge City were draped with black and patriotic bunting, with photographs of Lincoln placed in storefront windows. Cambridge City native and acclaimed artist Pam Bliss painted this larger-than-life mural of Lincoln's funeral train on the eastern wall of the Vinton House hotel block.

Pam Bliss utilized her artistic abilities when creating this mural of racehorse Single G, owned by W.B. Barefoot, of Cambridge City. Single G competed in 434 heats, winning 262 and placing in 418 heats. Over a career that spanned 14 years, Single G won $121,125. Single G retired from racing in 1927 in Centerville, where he had been born on April 4, 1910. The beloved racehorse died in 1940. A memorial was dedicated to Single G in Cambridge City on July 4, 1962.

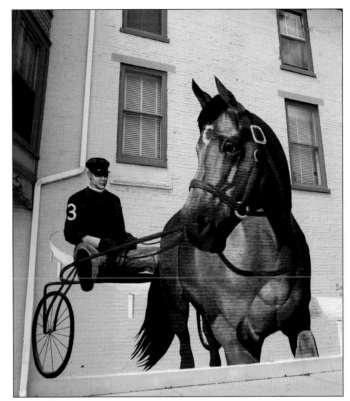

Leaning against the outer wall of a Cambridge City antique store is a hand-painted sign for Jody's Restaurant. In recent years, signs of this nature have grown in popularity with pickers and collectors.

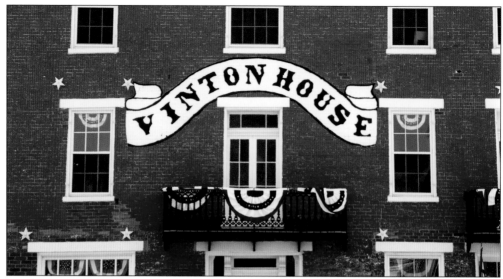

Cambridge City has numerous antique stores located on a two-block stretch of town known as "Antique Alley." The Vinton House stands among them. Built in the 1840s, the Vinton House is named after Eldridge Vinton, owner of the hotel from pre–Civil War times to the Progressive Era of Teddy Roosevelt. After Vinton died in 1908, his daughters took over ownership and operated the hotel until the Great Depression. In 1981, the Vinton House closed; it had been the oldest continuously operated hotel in Indiana. A decade after its closing, Western Wayne Heritage, Inc., saved the Vinton House from demolition. Today, it is known as one of the finest antique stores in the Midwest.

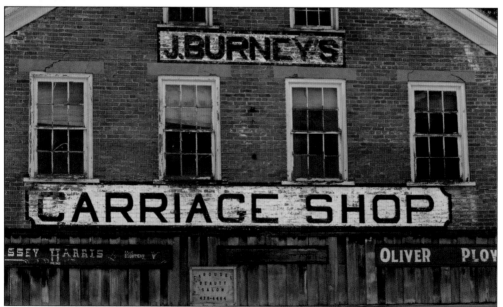

The building that once housed John Burney's Carriage Shop was built in approximately 1845 by Henry Jackson and used as the shop from 1880 to 1891. Restoration on the building, located in Dublin, began in 1978 by Lee and Cassie Lynch, with assistance from Icel Burchett. John Burney was born on August 24, 1849, in Wayne County, Indiana. Burney attended a private school in Dublin, where he learned the trade of carriage painting and trimming.

Nipper, the RCA dog, is included in this colorful storefront window for Wheeler's Antiques, located in Centerville.

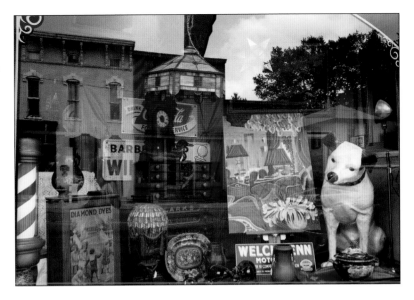

Gene Wallen owns and operates this Dublin antique store, where collectors can choose from a variety of items.

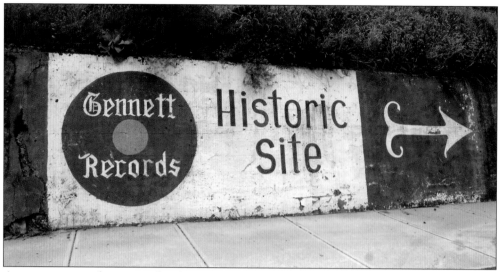

An arrow points the way to the Gennett Records Walk of Fame in Richmond. The Gennett Records Walk of Fame honors music legends who recorded for Gennett during the heyday of its operation.

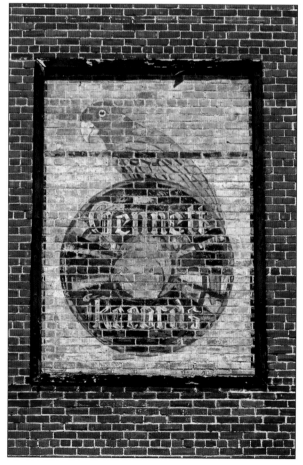

The Gennett Records parrot logo is painted on the south wall of the building that once housed the Starr Piano Company. Gennett Records is known for its contributions to early jazz, country, blues, and gospel music.

Jelly Roll Morton is one of 11 jazz greats featured in the Gennett Records Walk of Fame. The New Orleans–born pianist is considered by many to be one of the great innovators of jazz music.

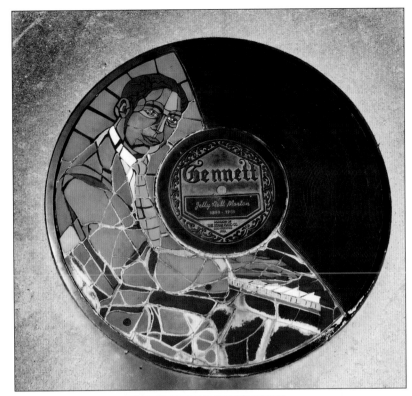

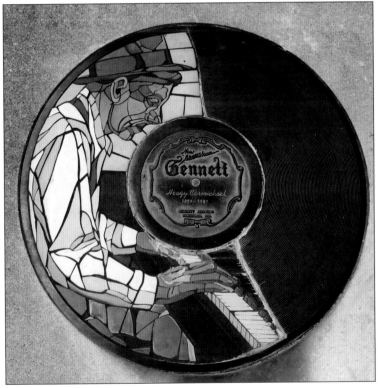

Legendary Hoosier composer Hoagy Carmichael is one of several musicians and composers honored on the Gennett Records Walk of Fame. Carmichael made his first recordings for the Gennett label in 1925. "Stardust," one of Carmichael's most famous compositions, was first recorded for Gennett in 1927.

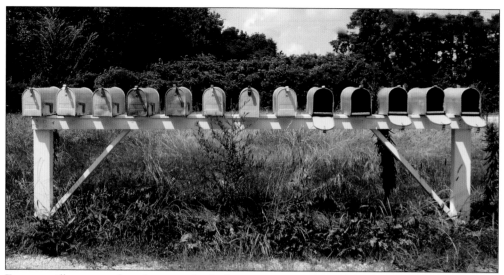

Empty mailboxes stand on the grounds of a former apartment complex in Dunreith. Prior to being converted into apartments, the structure was the site of the old Pine Manor Hotel.

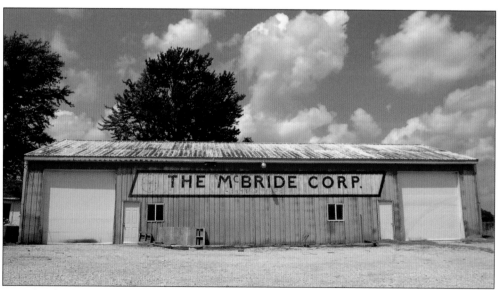

Cumulus clouds and blue skies hover above the building that once housed the McBride Corporation, a now defunct shipping company located in the town of Lewisville.

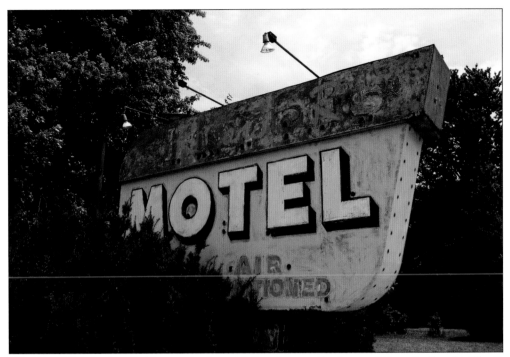

The R and R Motel in Dublin was built in 1953 and owned by Ray and Rose Podlewski. The R and R ceased operation in the early 1990s after 40 years of operation.

Rooms at the R and R Motel that were once filled with travelers, now stand empty and alone.

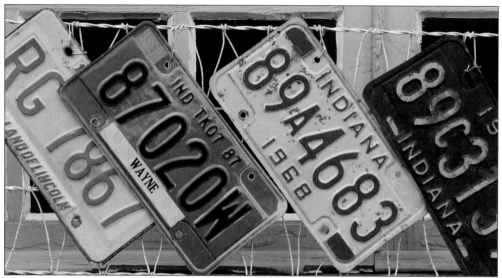

Old Indiana license plates, ranging from the 1960s through the 1980s, are displayed outside an antique store in Cambridge City.

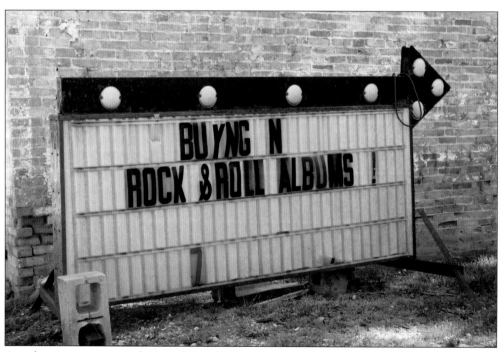

An advertisement sign seeking rock 'n' roll albums sits alongside a vacant building in Dunreith.

An empty two-story house with its front porch supported by bricks has been moved or destroyed since this photograph was taken.

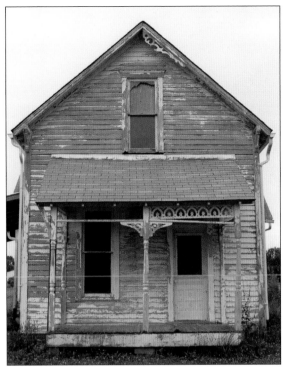

In this view looking east from the prosperous town of Cambridge City is a desolate stretch of Indiana's National Road.

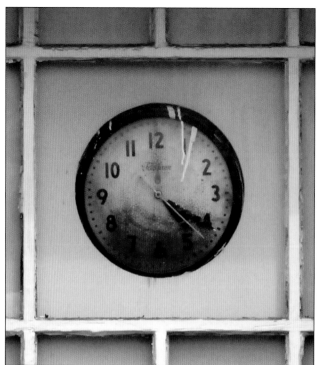

Suspended in time is this Telechron clock displayed above the Rusty Dusty Stuff antique shop in Cambridge City. Telechron, founded by Henry Ellis Warren, had its heyday between 1925 and 1955. The hands on this clock stopped ticking at 5:20.

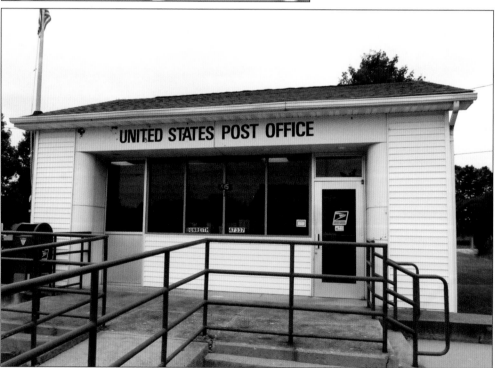

The Dunreith Post Office sits off Indiana's National Road, next to the Dunreith Community Building. The first rural route in Dunreith was established on October 1, 1900. Postal carriers served less than 200 residents in the small Indiana town.

Two

KNIGHTSTOWN
TO INDIANAPOLIS

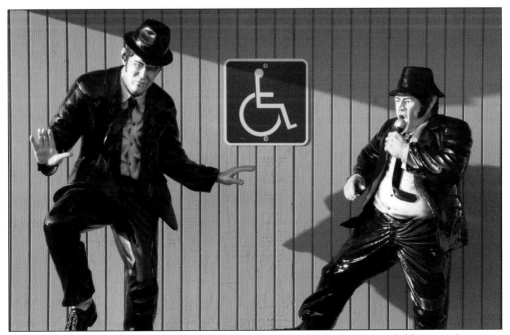

Figures of the Blues Brothers, Jake and Elwood, stand outside the Greenfield Music Center at the handicap parking space. The music center is under the ownership of Tony Seiler, who sells a variety of instruments and offers lessons to aspiring musicians.

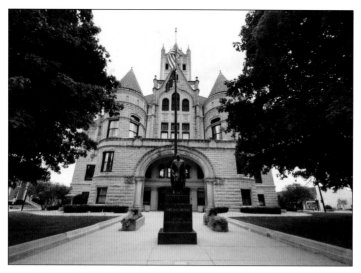

The Greenfield County Courthouse was built in 1835 and designed by architect John H. Felt. The courthouse is the focal point of the Greenfield Courthouse Square Historic District, listed in the National Register of Historic Places in 1985. On the sidewalk leading up to the courthouse is a statue of James Whitcomb Riley, who was born in Greenfield on October 7, 1849.

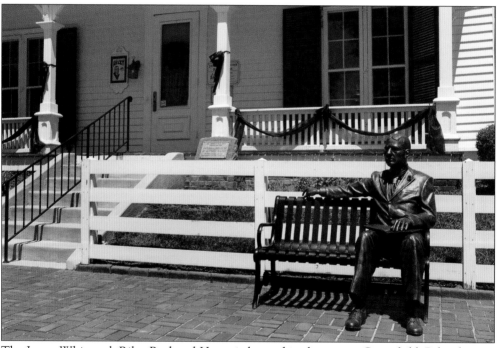

The James Whitcomb Riley Boyhood Home is located in downtown Greenfield. Riley, known as the "Hoosier Poet," was born in a log cabin on the present site of his boyhood home. When Riley was three years old, his father, Reuben, built the home where the family resided until 1864. It was purchased by the Hoosier Poet in 1893. The City of Greenfield bought the home from the Riley family in 1935. The James Whitcomb Riley Boyhood Home is listed in the National Register of Historic Places.

With a Fireworks Halloween sign looming in the background, a roadside business sign advertising daily tent meetings asks motorists to "Honk If U Know Jesus." The roadside sign has since been moved, but advertisement for the fireworks store still exists along East Washington Street in Cumberland.

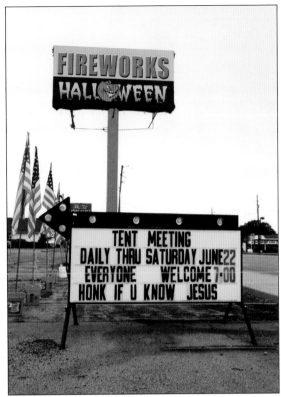

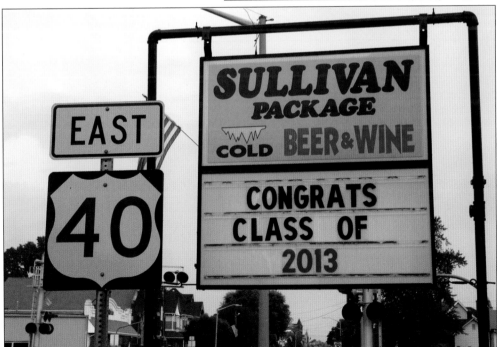

Sullivan Package Store in Knightstown congratulates the 2013 graduating class of Knightstown High School. Sullivan Package Store sells a variety of alcohol beverages.

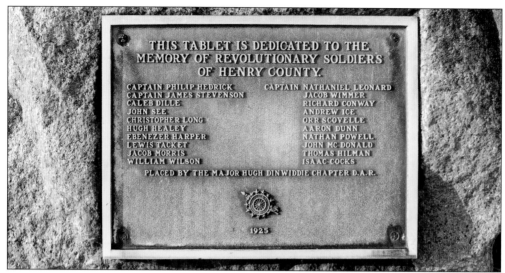

This Henry County Revolutionary War Memorial is displayed on the front lawn of the Knightstown Public Library. The memorial is dedicated to the memory of 20 Henry County men who served in the Revolutionary War. The Major Hugh Dinwiddie Chapter of the Daughters of the American Revolution orchestrated the project in 1925.

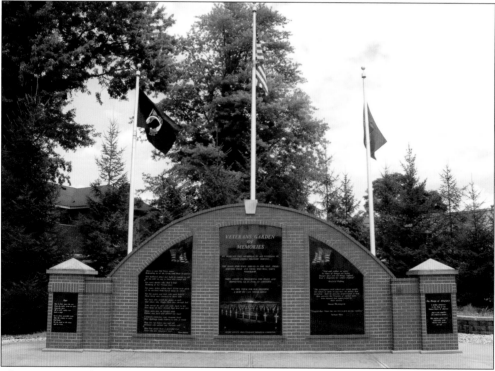

The Veteran Garden of Memories can be found at the Knightstown Public Square and is dedicated to the memory of all veterans of US military service. The memorial was dedicated in 2006 and sponsored by the Henry County Area Veterans Memorial Committee. Estimated cost of the memorial was $200,000. The Veteran Garden of Memories also features 1,700 engraved granite bricks lining the walkway to the memorial. John Love, of Knightstown, spearheaded the project.

A vintage television picture tube tester sits in a storefront window of an abandoned building in downtown Knightstown. During the 1960s, television picture tube testers were often found in drugstores, grocery stores, and hardware stores, where customers could diagnose picture tubes for free.

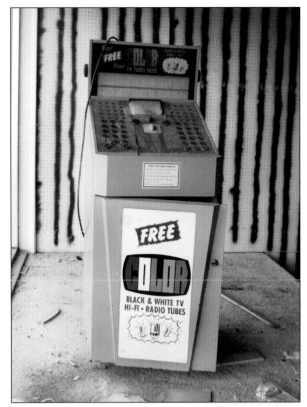

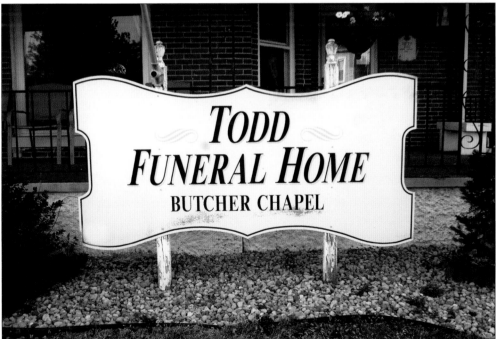

Prior to becoming Heritage Funeral Care, the Todd Funeral Home and Butcher Chapel operated at this same location and provided mortuary services for the Knightstown area.

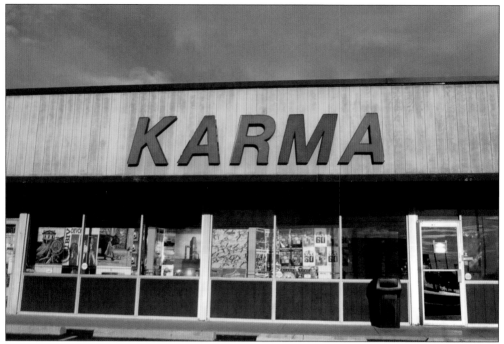

During the 1990s, about 30 Karma Records could be found in Indiana. Today, only six Karma Records remain open in the Hoosier State, including this Cumberland store located on the corner of Post Road and US 40.

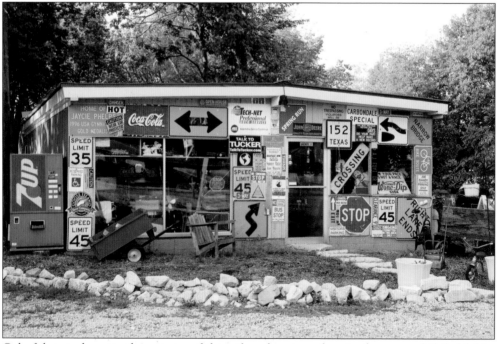

Colorful signs decorate the exterior of this gift and antique shop in the town of Philadelphia, named after the City of Brotherly Love. Philadelphia was platted in 1838, the same year that the town's post office was established.

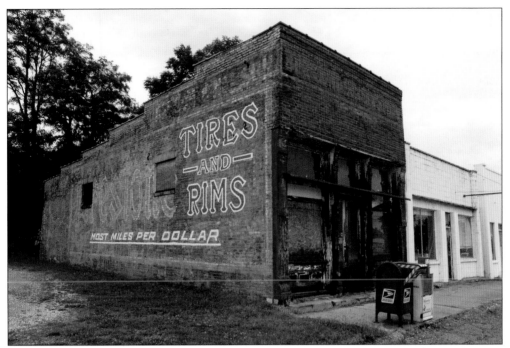

This vacated brick building in Charlottesville, with an advertisement for Firestone Tires, no longer stands. The structure fell victim to the wrecking ball sometime after this photograph was taken.

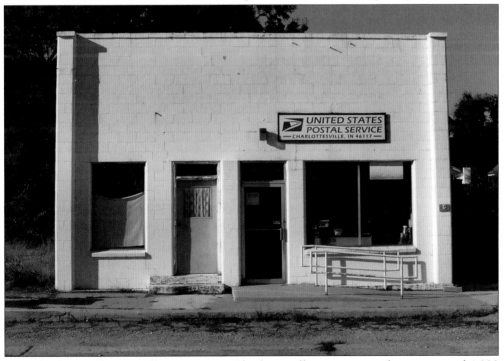

The Charlottesville Post Office serves 671 Charlottesville customers with an estimated 1,000 packages passing through the post office each year. The Charlottesville Post Office has been in operation since 1831.

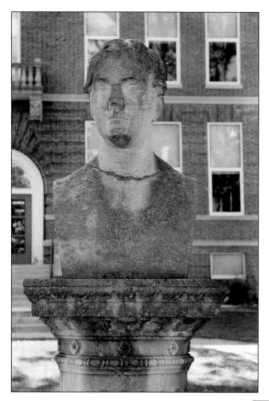

A bust of author Washington Irving stands in the Irvington Historic District, east of downtown Indianapolis. Irving is best known for his short stories "Rip Van Winkle" and "The Legend of Sleepy Hollow." The Irvington Historic District was founded in 1870. Historic mansions, parks, art galleries, small businesses, and eateries have made the Irvington Historic District one of the more popular neighborhoods in the Indianapolis area.

In 1913, the Irving Theatre, in Indianapolis, first opened its doors to the public. At the time, the Irving Theatre showed popular silent films of the day. In 1926, the theater expanded and became a small Indianapolis shopping mall. During the 1970s, the Irving Theatre was turned into an adult movie house; it eventually closed in the mid-1990s. After a much-needed renovation, the Irving Theatre reopened in 2006 and features live music and performance artists. In 2012, the Irving Theatre held a folk festival to celebrate the 100th birthday of Woody Guthrie.

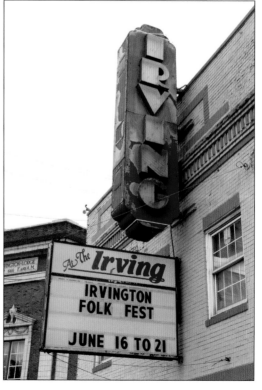

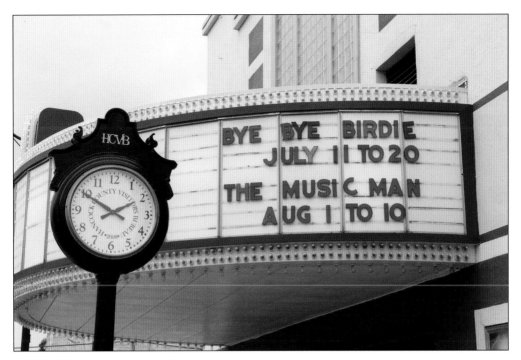

H.J. Ricks Centre for the Arts is located in the heart of historic downtown Greenfield and operates within a renovated and restored 1946 Art Deco/Art Moderne–style movie house. The 386-seat facility hosts a variety of live productions, including plays, musicals, and concerts. For many years, the building was the site of the Weil Theatre, which was built by Walter "Pug" Weil at a cost of $100,000 and opened on November 1, 1946. The first movie shown at the theater was *Caesar and Cleopatra*, starring Claude Rains and Vivien Leigh. In the late 1980s, it adopted the name Village Theatre before becoming the present-day H.J. Ricks Centre for the Arts.

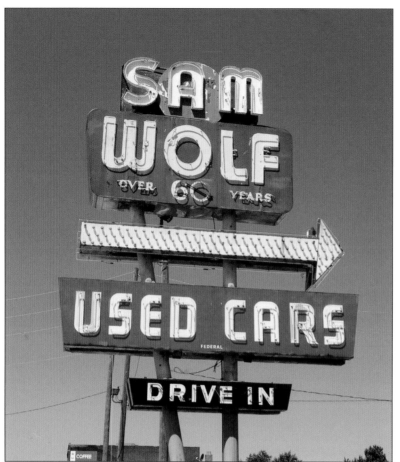

Sam Wolf Used Cars may no longer be in operation; however, the sign advertising the business east of Indianapolis brings back a sense of nostalgia to passing motorists on Highway 40.

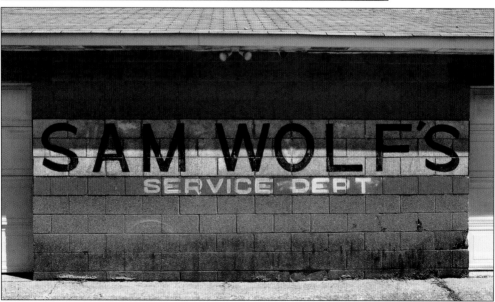

Sam Wolf's Service Department was located in the rear of a used car business.

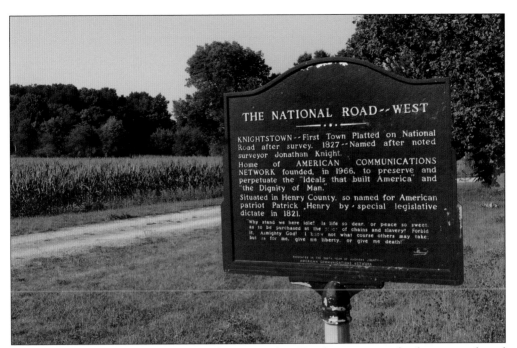

A historical marker along Indiana 40 designates that Knightstown was the first town platted on the National Road. Henry County, where Knightstown is located, is named after American patriot Patrick Henry.

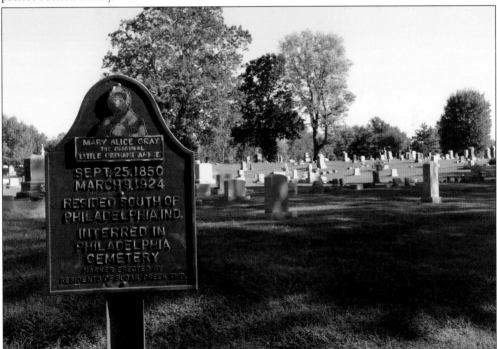

A memorial marker for Mary Alice Gray stands at the west entrance of Philadelphia Cemetery. Gray was the real-life subject of James Whitcomb Riley's poem "Little Orphant Annie." Gray died in 1924 and was laid to rest in the Philadelphia Cemetery, just west of Greenfield.

St. John United Church of Christ, located on the corner of German Church Road and Washington Street, was completed in 1914. The church was founded by German settlers who inspired the naming of German Church Road. Today, the boarded-up church is closed; the congregation held its last service in October 2015. The historic landmark was scheduled for demolition but money raised by the church congregation saved the building from being razed.

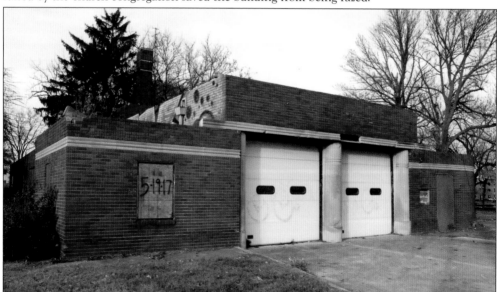

Old Fire Station 18, on Washington Street in Indianapolis, was built in 1936 and closed in 1994. Architects Edward D. Pierre and George Caleb Wright designed the Art Deco–style station that has become a canvas for graffiti artists. Indiana Landmarks has placed the deteriorating fire station on its "10 Most Endangered" list.

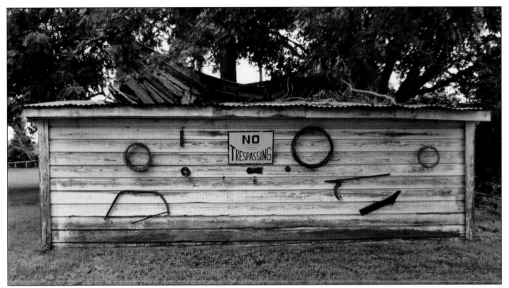

Within a short distance of Cumberland's business district is a decrepit shed sitting on vacant property. A No Trespassing sign and old farm tools adorn the aged shed, in need of repair.

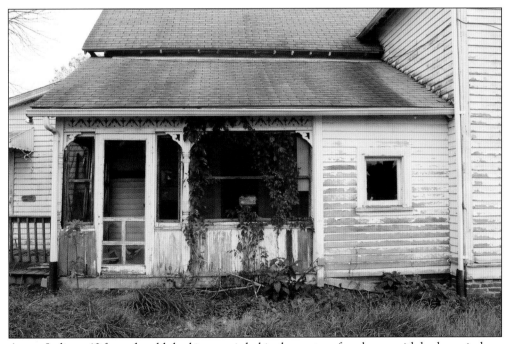

Across Indiana 40 from the old shed is an uninhabited two-story farmhouse with broken windows and doors. On the same property are two barns, a shed, and garage. Overgrown weeds and tall grass consume the land that may have been a successfully operated farm.

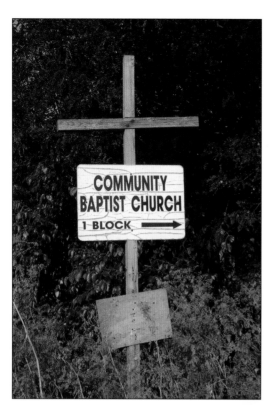

A simple wooden cross points the way to the Community Baptist Church located one block off Indiana's National Road in Knightstown.

Motorists traveling on Indiana 40 see a variety of signs letting them know that they are traveling Indiana's National Road. This particular sign is on the outskirts of Knightstown.

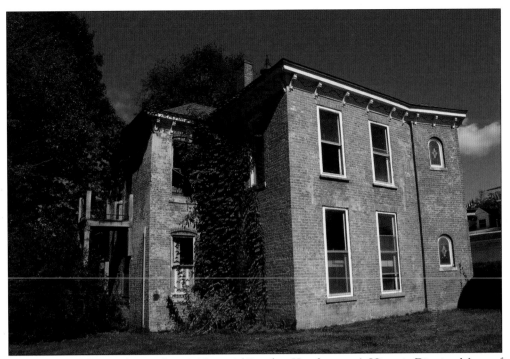

Beautiful brick homes line Indiana's National Road in Knightstown's Historic District. Many of the homes here were built during the 19th century by prominent Knightstown businesspeople. In 1986, Knightstown was added to the National Register of Historic Places.

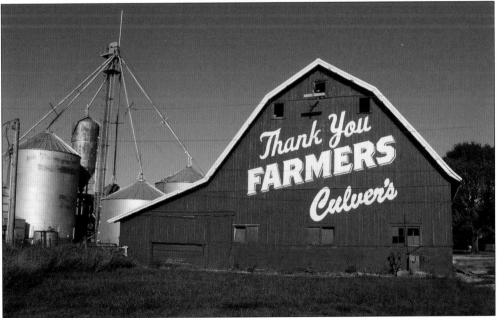

In 2013, Culver's began painting barns blue to show its appreciation to the American farmer. The "Thank You Farmers" campaign not only supports food producers but donates money to the Future Farmers of America. Culver's has a long-standing relationship with America's farmers and ranchers.

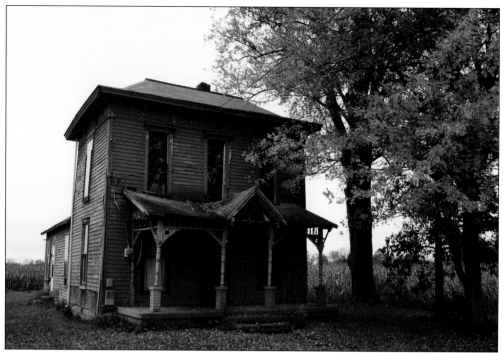

Revenant Acres Farm is an old haunted farmhouse in Charlottesville and a hot spot for paranormal activity enthusiasts. In 1826, Josiah VanMeter Sr. purchased 30 acres of land where the farmhouse now sits. Today, tours are offered at the site and the facility can be rented by those who are curious to see if the house is truly haunted.

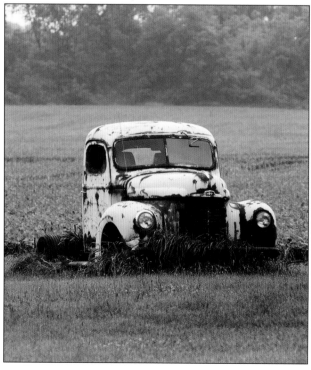

A rusted truck that has long been out of commission rests near a field on Revenant Acres Farm.

Hancock County Veterans Park in Greenfield was dedicated on May 10, 2010. The park was created to honor all veterans of Hancock County who served in the military, past and present. The project began in 2008 and was made possible through monetary donations and sales of brick pavers that bear the names of veterans with ties to Hancock County. Total cost of the construction was $300,000. Beautiful granite monuments tell stories of wars and conflicts that the US military has engaged in.

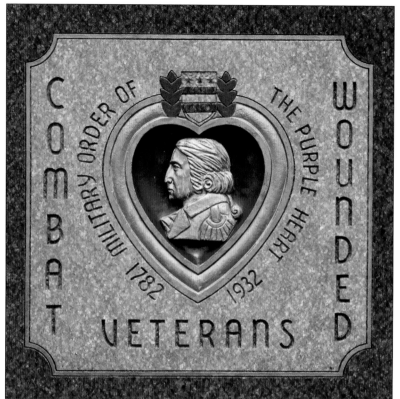

A monument at Hancock County Veterans Park honors combat veterans who are recipients of the Purple Heart. The first Purple Heart was awarded in 1932. An estimated one million Purple Hearts were awarded to combat veterans of World War II.

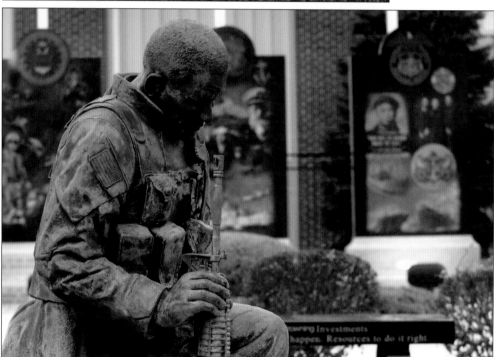

Pictured is a statue of a weary soldier kneeling with his gun at Hancock County Veterans Park.

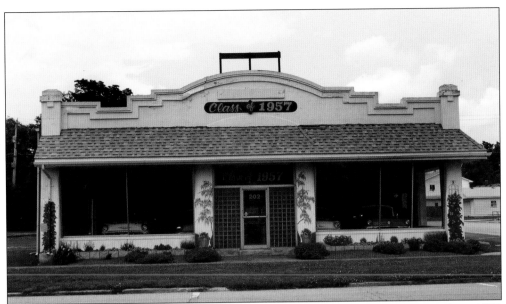

The Class of 1957 is a privately owned museum in Knightstown that exhibits everything 1957. Letter jackets, 33 and 45 rpm records, and assorted classic cars from 1957 are on display at the Class of 1957.

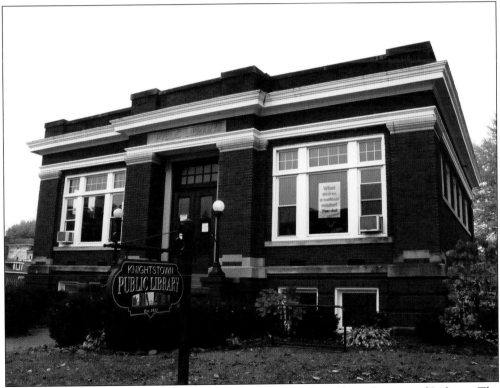

In the early 1900s, an estimated 164 Carnegie libraries were built in the state of Indiana. The Knightstown Carnegie Library, opened in 1912, was constructed at a cost of $10,000.

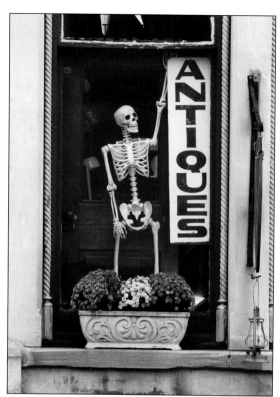

Perfectly framed in the window of a Greenfield antique store is a skeleton welcoming shoppers inside.

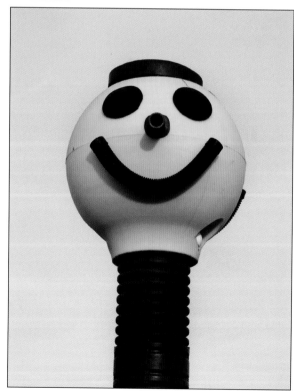

Motorists traveling in the Greenfield area on Indiana's National Road are apt to notice this smiley face figure standing outside the Galloway Group, Inc.

American Legion Post 152, in Knightstown, uses a red, white, and blue mailbox to collect American flags ready for proper retirement.

Though the donkey is the emblem of the Democratic Party, it has never been officially adopted. The same cannot be said for the rooster. Joseph Chapman, a Greenfield native and Democratic state legislator, was criticized by the Whigs for "crowing" during his speeches. While campaigning for a seat in the lower house of the Indiana Legislature, the Whigs chanted "Crow, Chapman, Crow!" toward the Democrat. Members of the Democratic Party seized on the moment and used "Crow, Chapman, Crow!" throughout Chapman's campaign. Chapman was elected to the Indiana Legislature and from that day forward was known as "Crowing Joe Chapman." In 1840, the rooster became the official emblem of the Democratic Party. In 1966, the Indiana Sesquicentennial Commission erected this historical marker on Indiana 40 near Riley Park in Greenfield.

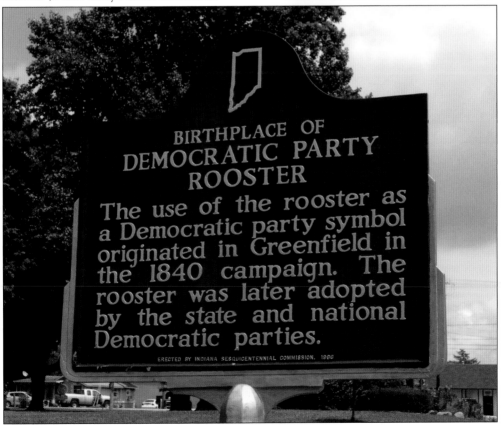

Hand-painted signs are a common practice for small business owners along Indiana's National Road, including this auto dealership sign near the town of Gem.

Frosty Boy Restaurant and Pizza King operate within the same facility in Knightstown. In 2017, Frosty Boy celebrated 45 years as a business. Pizza King, known for its slogan "Ring the King," has several pizza parlors located throughout central Indiana.

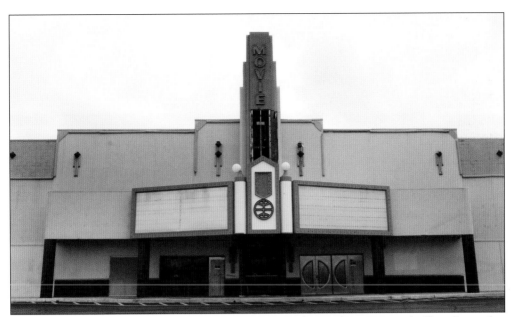

Cinemark East Washington Street 8 opened its doors to Indianapolis area movie buffs on September 1, 1989. The once popular cinema, located at 10455 East Washington Street, closed in August 2014. The cinema is currently up for sale.

A Pepsi machine selling canned pop for 50¢ stands outside a vacated building in Knightstown.

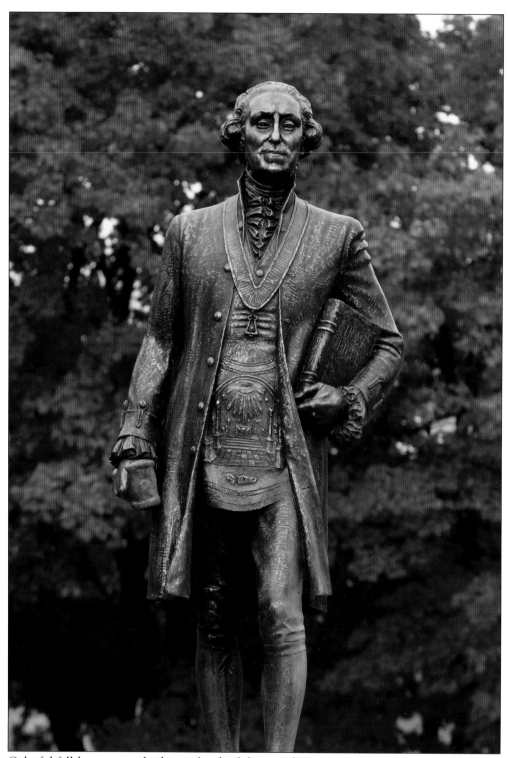

Colorful fall leaves provide the perfect backdrop to this statue of Pres. George Washington overseeing George Washington Court at Washington Park East Cemetery in Indianapolis.

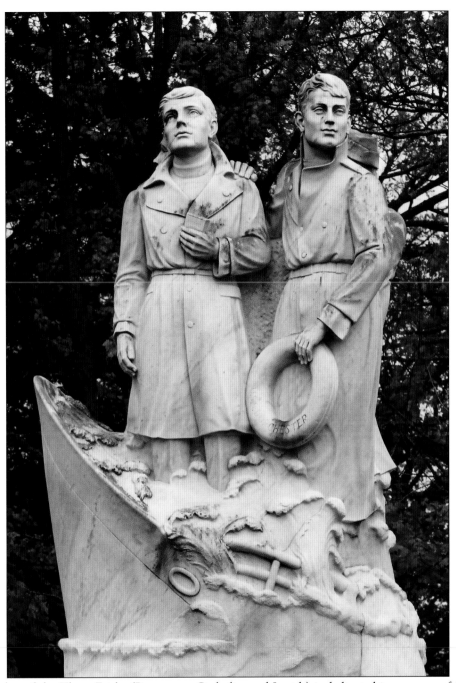

Garden of the Three Faiths (Protestant, Catholic, and Jewish) is dedicated in memory of four heroic chaplains who sacrificed their lives to save others during World War II. On February 3, 1943, an enemy torpedo struck the troop ship SS *Dorchester*, with Greenland as its destination. Before the ship sank, Fr. John P. Washington, Rev. George Lansing Fox, Rabbi Alexander D. Goode, and Rev. Clark V. Poling helped soldiers board lifeboats and gave their own life jackets away when the supply was gone. The four chaplains joined arms, prayed, and sang hymns as they went down with the ship.

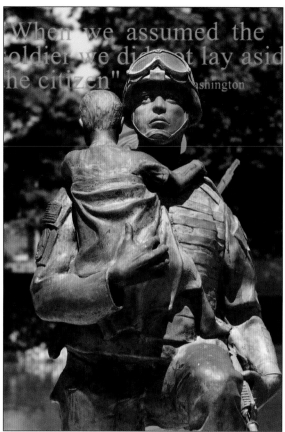

On November 8, 2007, the Hoosier Patriot Memorial was dedicated at Washington Park East Cemetery. Members of the Sons of the American Revolution attended the ceremony dressed in authentic Revolutionary War uniforms. Unveiled at the event was the bronze statue *The Rescue*, created by sculptor Bill Wolfe. The statue depicts a guardsman in a kneeling position, rescuing a small child. Behind *The Rescue* stands a glass backdrop with a quote from George Washington that reads, "When we assume the soldier, we do not lay aside the citizen." The Hoosier Patriot Memorial honors the Indiana National Guard, and is the first memorial in the country dedicated to a state's National Guard.

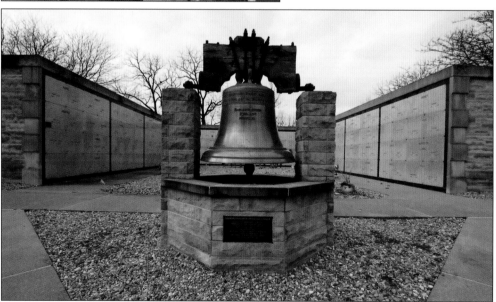

The Paccard Bell Foundry, of Annecy-le-Vieux, France, cast this replica of the Liberty Bell that is featured in the Garden of Freedom at Washington Park East Cemetery. Dedication of this Liberty Bell took place on May 5, 1996.

Greenfield's Riley Park covers 40 acres of land and features a skate park, basketball and tennis courts, baseball diamonds, a playground area, and fishing along Brandywine Creek. In addition, there is a swimming pool, pavilion, and shelter house.

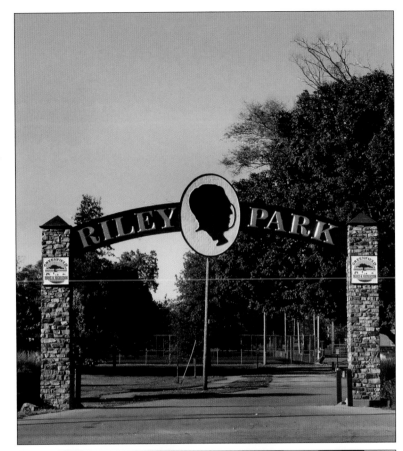

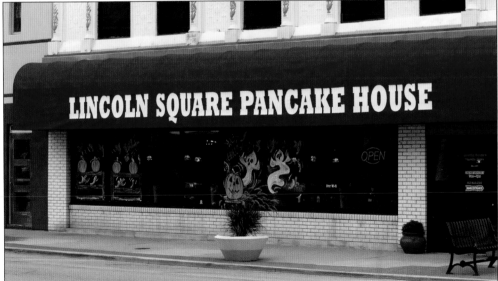

Lincoln Square Pancake House in Greenfield was founded in 1989 by George Katris. The popular family-owned restaurant offers a variety of delicacies to satisfy hungry customers for breakfast, lunch, and dinner.

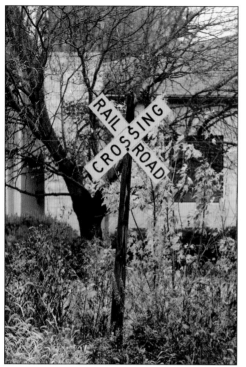

Weeds grow in and around this railroad crossing in Knightstown, just off US 40. Tom Allison's "Big Blue Engine" once used the tracks to take children on pumpkin picking train rides. The last run for the "Big Blue Engine" was in 2014.

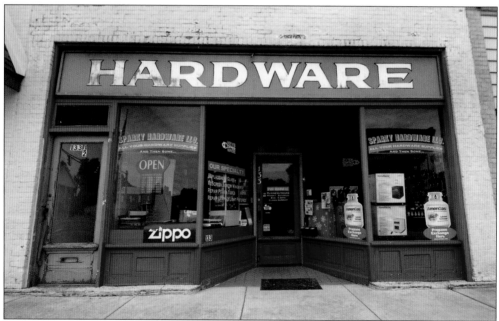

With the growth of chain home improvement stores, neighborhood hardware stores are slowly becoming a thing of the past. The independently owned hardware stores of yesterday sold baseball gloves, bicycles, nuts, bolts, nails, doorknobs, locks, and custom-made keys. More importantly, hardware stores played an important role in the local business community. In recent years, Sparky's Hardware in Knightstown (pictured) and a second store in Cambridge City closed their doors to faithful customers.

Just west of the Historic Irvington District are several closed businesses with boarded-up windows and Keep Out signs that have fallen by the wayside to larger companies.

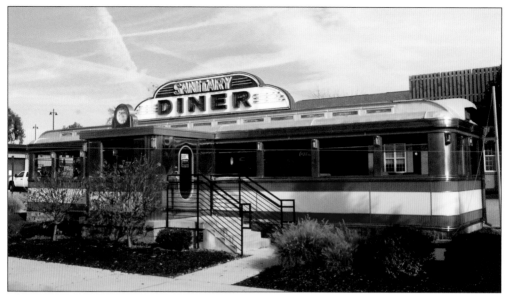

The hidden yet popular Sanitary Diner offers a variety of foods, drinks, tea, and coffee on its menu and has been referred to as the best espresso in Indianapolis.

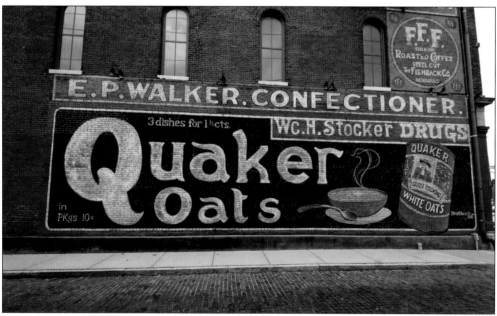

Artists Christopher Blice and Jon Edwards painted this mural on the side of the Angie's List building in Indianapolis. The artists brought back to life the faded original painted billboard advertisement for Quaker Oats, roasted coffee, and candies.

The Soldiers' and Sailors' Monument in Indianapolis was dedicated on May 15, 1902. Built between the years of 1888 and 1901, the monument was designed by German architect Bruno Schmitz. Standing at over 284 feet, the Soldiers' and Sailors' Monument was the first of its kind in the United States dedicated to the common soldier. On February 13, 1973, the monument was added to the National Register of Historic Places. During the holiday season, the Soldiers' and Sailors' Monument is decorated, making it the largest Christmas tree in the world.

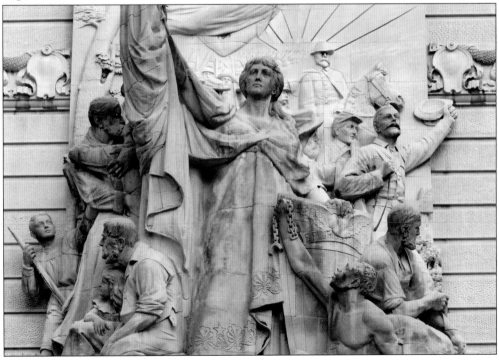

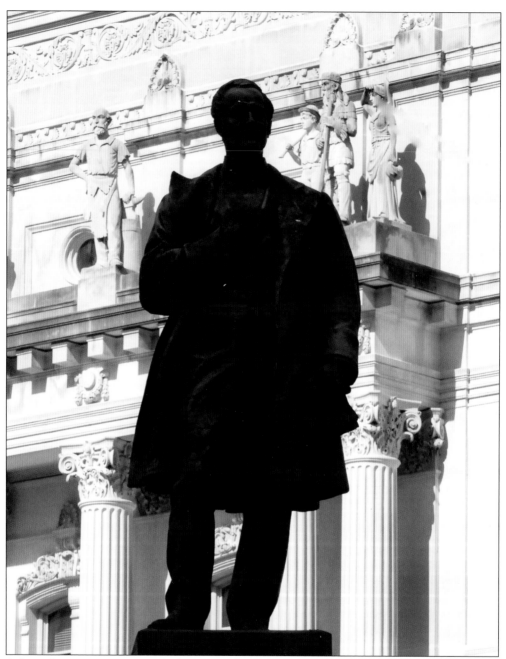

A late afternoon sun casts a shadow upon the statue of Thomas A. Hendricks at the Indiana Statehouse in Indianapolis. Hendricks served as 16th governor of Indiana (1873–1877) and 21st vice president of the United States (1885). The Democrat later represented Indiana in the US Senate (1863–1869). Hendricks died on November 25, 1885, and is buried at Crown Hill Cemetery in Indianapolis.

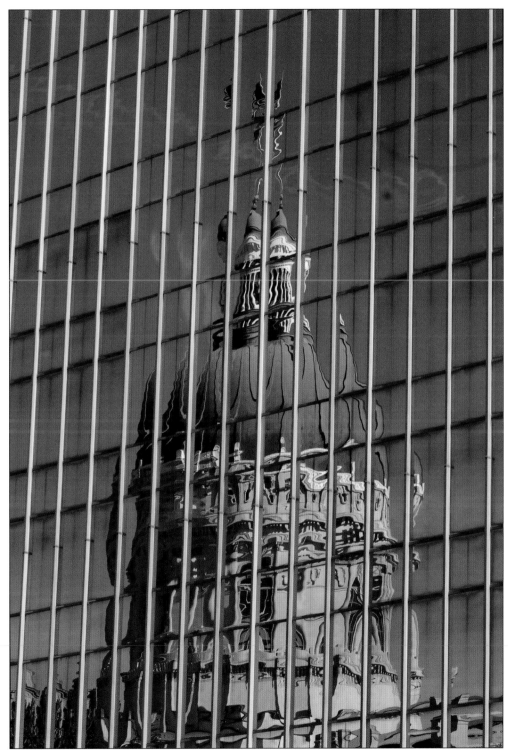

A reflection of the Indiana Statehouse is seen in an office building across the street from the facility.

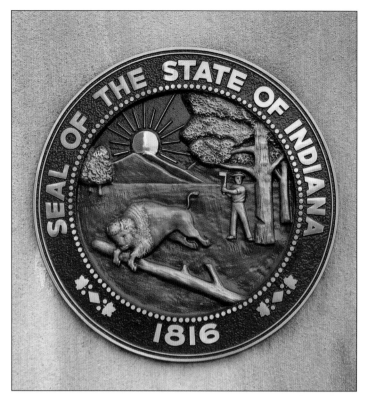

Several monuments line Washington Street in downtown Indianapolis, including the seal of the State of Indiana. The seal is used by the governor of Indiana to certify the authenticity of legal documents. Indiana was admitted to the Union on December 11, 1816, as the 19th state.

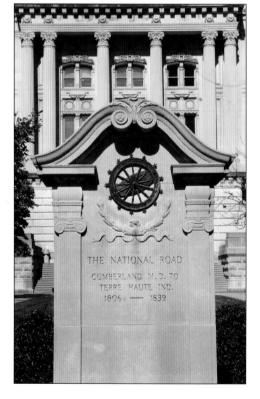

THE NATIONAL ROAD
CUMBERLAND M.D. TO
TERRE HAUTE IND.
1806 —— 1839

Standing on the south lawn of the Indiana Statehouse is a monument commemorating the role of the National Road in the development of Indiana. The limestone monument was placed here in 1916 by the Caroline Scott Harrison Chapter of the Daughters of the American Revolution.

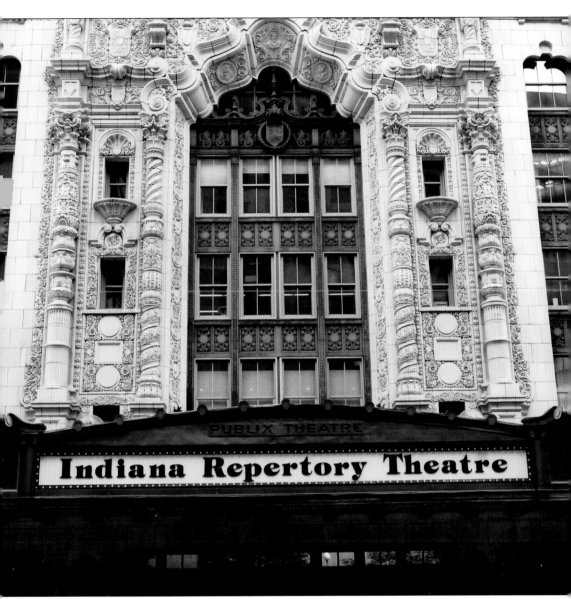

The Indiana Repertory Theatre operates within a building dating back to 1927. The Indiana Repertory Theatre, otherwise known as the IRT, averages 10 plays per season, including a production of Charles Dickens's *A Christmas Carol* during most holiday seasons.

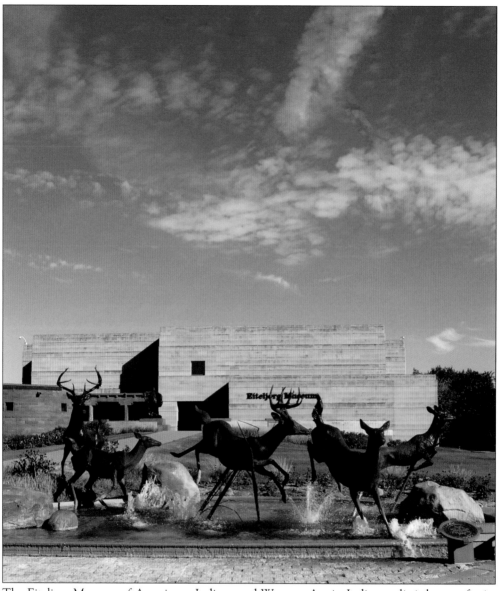

The Eiteljorg Museum of Americans Indians and Western Art in Indianapolis is known for its extraordinary collection of Native contemporary art. The sculptures and paintings displayed in the museum are from the collection of philanthropist and businessman Harrison Eiteljorg. The museum was founded in 1989 and is located on the grounds of White River State Park.

Tibbs Drive-In Theatre opened in 1967 and is the only remaining Indianapolis drive-in theater. Located off US 40 on Tibbs Avenue, the drive-in theater has four screens for movie buffs to choose from. There was a time when Indianapolis had an estimated 18 drive-in theaters but those have since closed for business. Today, there are only 19 drive-in theaters remaining in the state of Indiana.

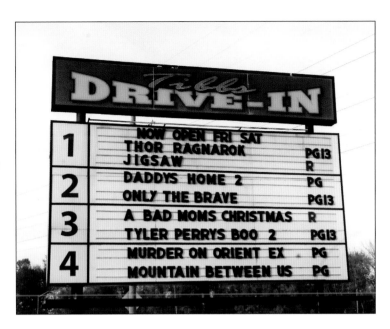

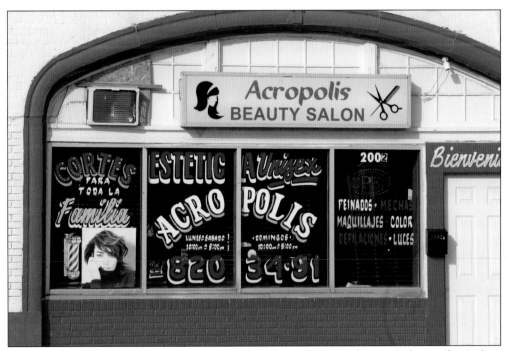

Acropolis Beauty Salon has one of the more colorful storefront windows in Indianapolis. Stylists offer clients a variety of services—including highlighting, coloring, and hairstyling—at the family-owned business.

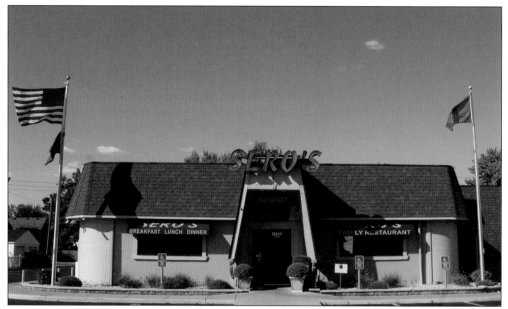

Sero's Family Dining has been owned and operated by the Lulgjurajs family for nearly 20 years. Open seven days a week in the heart of Cumberland, Sero's provides a relaxed atmosphere to customers who enjoy breakfast, lunch, or dinner.

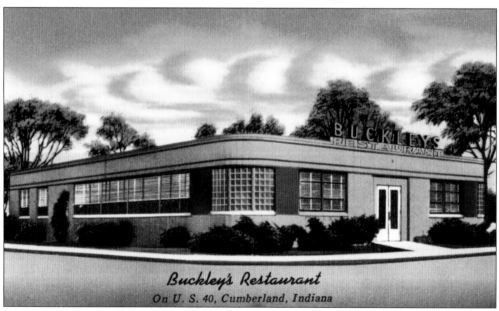

Buckley's Restaurant
On U. S. 40, Cumberland, Indiana

Prior to becoming Sero's Family Dining, Buckley's Restaurant operated from the same location on US 40. Buckley's opened in 1922 and was known to serve over 60,000 chicken dinners per year.

Three

PLAINFIELD TO
TERRE HAUTE

In the small town of Manchester stands the Manhattan Christian Church. Built in 1838, the church seats 75 to 100 people. Manhattan Christian Church no longer holds Sunday church services but continues to have monthly prayer meetings.

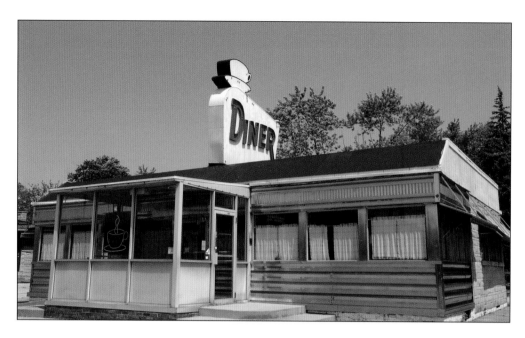

With its rooftop sign featuring a cup of coffee, the US 40 Diner in Plainfield outlasted many roadside Indiana diners. But in 2009, the US 40 Diner (also known as the Oasis) closed. This led Indiana Landmarks, a group that fights to save historic places, to put the 1954-built diner on its "10 Most Endangered" list of Indiana historical sites in danger of being demolished. Luckily, the US 40 Diner was saved and moved to a new location in Plainfield. It now goes by the name Oasis Diner.

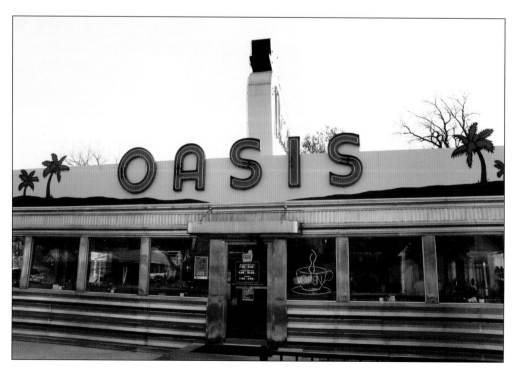

This retro Indiana State Police sign stands on the lawn of the Putnamville Indiana State Police Post District 53 in Putnam County. The neon sign dates back to the 1950s.

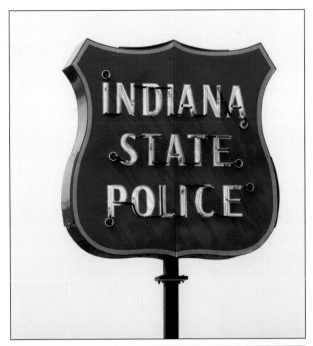

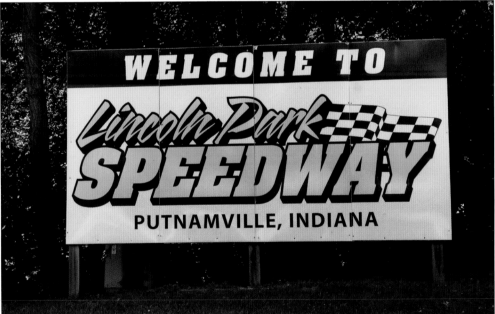

Lincoln Park Speedway was established in 1969 by Kenny Farland, who owned the quarter-mile track through 1972. It was then that Buck Arnold took over ownership and built concrete grandstands on the north side of the track. In 1982, new racetrack owners Mike and V. Farrar expanded the corners by 20 feet and made Lincoln Park Speedway into a 5/16th-mile track. Since its opening in 1969, Lincoln Park Speedway has hosted spring car racing, tractor pulls, Figure 8s, and spectator races. Future Indy Car and NASCAR driver John Andretti won his first Sprint Car race in 1984 at the Putnamville track. In 1992, Bob Kinser won his seventh Sprint Car title at the age of 61.

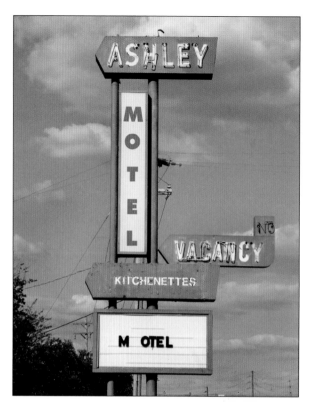

Ashley Motel in Plainfield dates back to the 1950s. There was a time when over 120 motels were located along Indiana's National Road. Today, only a few motels along US 40 remain in operation.

The Walker Motel in Cloverdale is, perhaps, one of the more photographed sites along Indiana's National Road. Though weathered with age, the old sign on the front lawn remains intact from the motel's early days of existence. Behind the old Walker Motel lies a section of the original National Road. Motorists can drive down a hill behind the motel to a concrete bridge that runs over Deer Creek. The bridge served as the only way across the creek until the highway was rerouted to its current location.

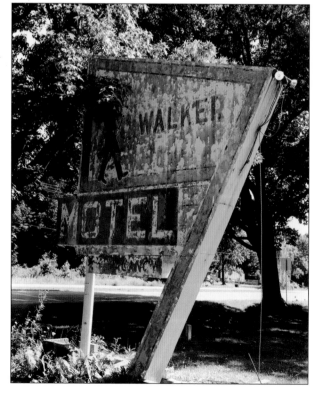

All that is left of the 40 Motel in Plainfield is this sign that escaped destruction. The 40 Motel was located at 9750 West Washington Street. However, after this photograph was taken, the 40 Motel sign was removed from the property.

Kendall's Garage in Manhattan began operation in the 1950s. The original owner was Frank Kendall, who later turned the family business over to his son Ed. Records indicate that Kendall's Garage closed in the late 1990s or possibly the early 2000s. The white brick building is nearly gutted and descending to the ground.

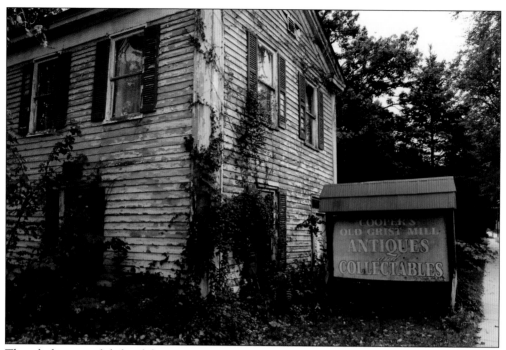

Though the sign is faded and the property is overgrown with weeds, Cooper's Old Grist Mill Antiques and Collectables in Stinesville remains a picturesque site to photographers and artists.

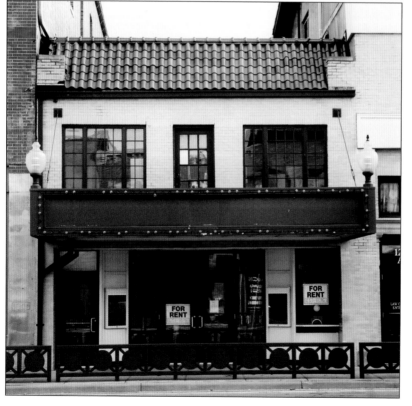

The Village West Theatre in Plainfield was originally known as the Prewitt Theatre, which was built on the site of the Princess Theatre. The Prewitt Theatre was built in 1927 by L.M. Prewitt, who also served as its architect. The Village West Theatre closed on June 1, 2008, and the building has sat empty ever since.

Al's Donuts in Plainfield first opened its doors to customers in 1960. The old-fashioned donut shop attracts customers from as far as Dayton, Ohio. Al's menu includes pecan rolls, yeast and cake donuts, bismarcks, cowpatties, cinnamon rolls, and rawhides. The donut shop opens early and closes its doors once the inventory runs out.

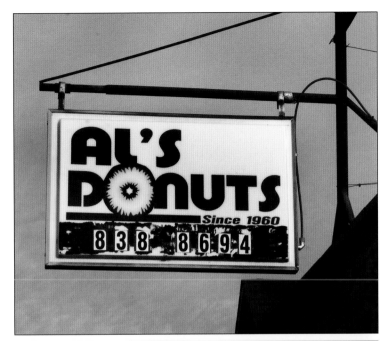

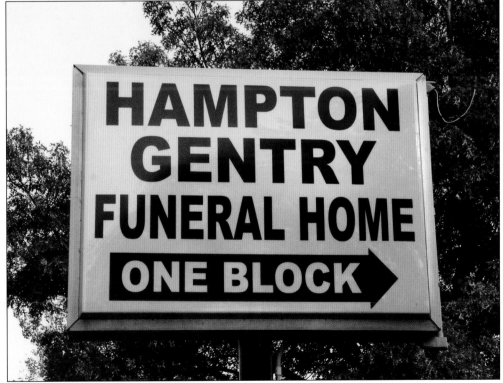

Motorists traveling through Plainfield are reminded that the Hampton Gentry Funeral Home is one block south of US 40. The funeral home was founded in 1874 by Samuel Hiss, who operated his mortuary in downtown Plainfield. Hampton Gentry Funeral Home has been at its current location since 1950.

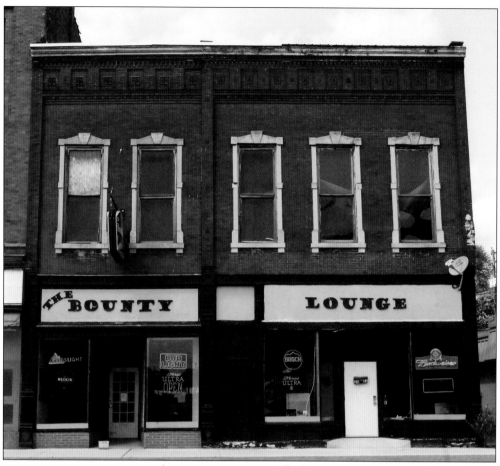

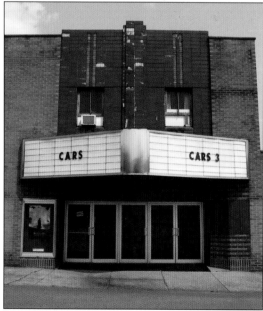

The Bounty Lounge in Brazil began operation in 2009 and is owned by Jeff Warren. With a variety of liqueurs to choose from, the Bounty Lounge has one of the largest dance floors in the area with a state-of-the-art light and sound system.

Walnut Theatre sits off the National Road in downtown Brazil and has been under the ownership of Mark and Gayla Thiemann for over 20 years. The Walnut Theatre once went by the name Cooper Theatre, which opened in February 1948. The Walnut Theatre has been in operation at this site since the late 1950s.

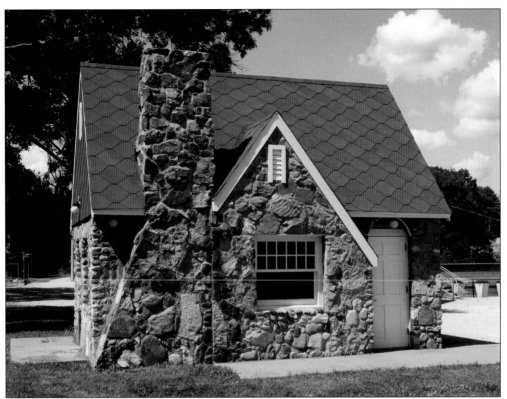

On the western end of Rose-Hulman Institute of Technology stands this 1931 gas station building. A few years ago, the small structure was in danger of being razed but was saved from destruction by members of the Indiana National Road Association and Rose-Hulman Institute of Technology. The gas station was originally located in downtown Terre Haute but was moved to the grounds of Rose-Hulman Institute of Technology where it remains today.

Krambo's Kustom Kolors in Manhattan opened in 2008 and specializes in building, painting, and restoring motorcycles. Krambo's operates within a 100-year-old building that once was a Texaco station owned by Lloyd Fellows. Outside Krambo's Kustom Kolors sits a 1955 Ford panel truck.

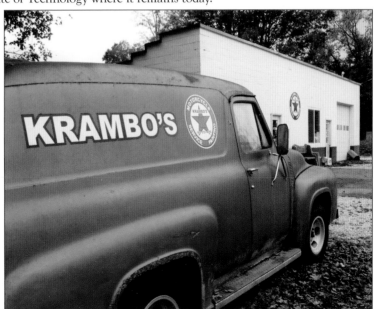

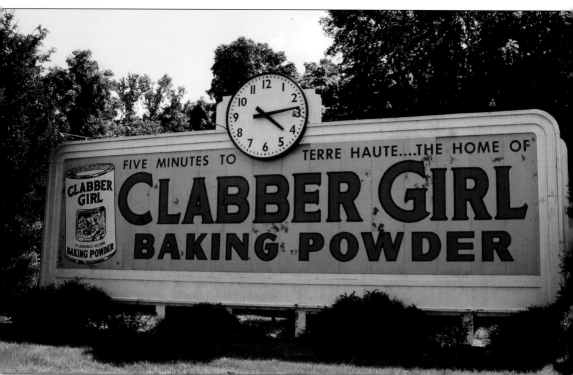

In 1850, Francis and Herman Hulman founded Hulman and Company, headquartered in Terre Haute. In 1858, Hulman and Company opened a wholesale grocery store. By 1899, the Clabber brand baking powder was introduced, officially named Clabber Girl in 1923. Tony Hulman Jr. started a nationwide campaign to promote Clabber Girl Baking Powder in 1930. Fifteen years later, Hulman purchased the Indianapolis Motor Speedway to further promote Clabber Girl. Today, Clabber Girl continues to expand its business, purchasing Fleischmann's Baking Powder and Royal Dessert mixes in recent years. The word *clabber* refers to sour milk that has thickened or curdled.

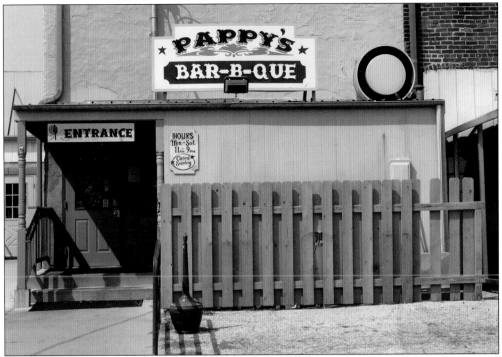

Pappy's Bar-B-Que and General Store is located in downtown Brazil. The restaurant is owned and operated by Rick Bell, who opened the business in January 2007. Pappy's menu includes chili, brown sugar corn bread cake, pulled pork, meat loaf, and Poppy's Poppers. Located inside Pappy's Bar-B-Que and General Store is an old-fashioned Coca-Cola cooler with iced bottled Cokes.

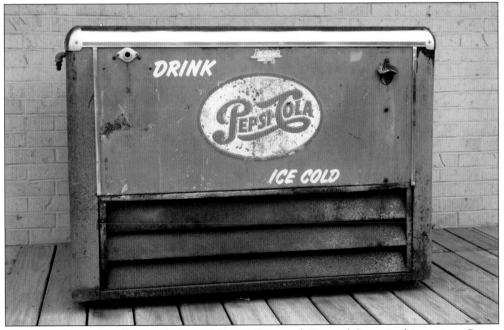

Sitting on the sidewalk outside Pappy's Bar-B-Que and General Store is this antique Pepsi-Cola machine.

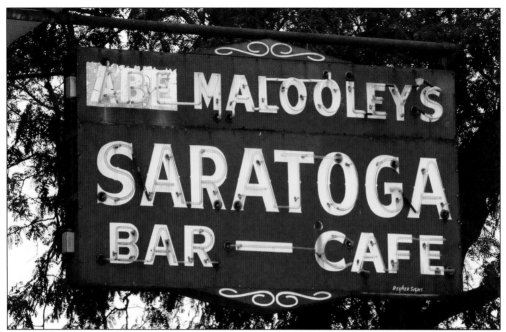

Joseph Malooley purchased Saratoga Bar and Café in 1942 from attorney N. George Nasser. Shortly afterward, Joseph asked his younger brother Abe to help run the Terre Haute–based business. In the 75 years that the Saratoga Bar and Café has been open, it has always been a family-owned business.

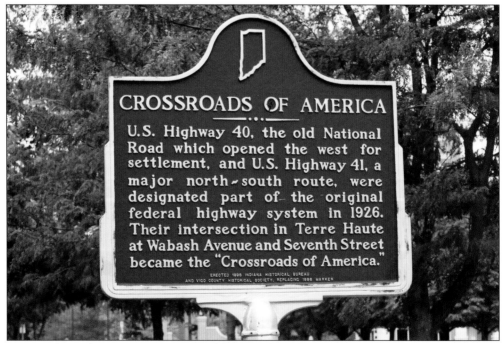

From Richmond to Terre Haute, several historical markers have been placed along Indiana's National Road, including "The Crossroads of America" in Terre Haute. The historical marker was erected on July 4, 1988, by the Vigo County Historical Society.

Rising Hall, located just outside Stilesville on Indiana 40, was built by Melvin F. McHaffie in 1872. The cost of the Italianate home was $2,500. McHaffie raised mules and provided the Union army with the largest number of mules during the Civil War. In later years, McHaffie's son Ernest operated the farm as a breeding and training facility for race horses.

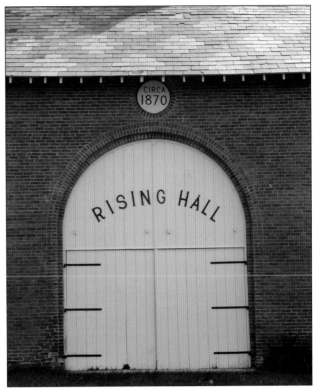

The Clay County Historical Society Museum is located on the National Road in downtown Brazil. The museum is housed in the former Brazil Post Office, which opened in February 1913. In 1974, it was announced that Brazil would obtain a new post office. The old post office was purchased by the Clay County Historical Society for an estimated $31,000. After repairs were made to the building, the museum was dedicated in July 1980.

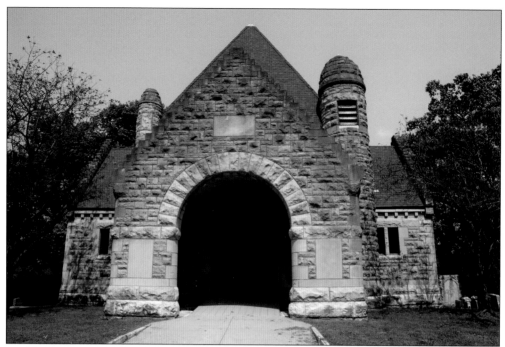

Highland Lawn Cemetery in Terre Haute was established in 1884 and sits on 139 acres of land. The historic cemetery features a Richardsonian Romanesque chapel built in 1893 by architect Jesse A. Vrydaugh, a bell tower constructed in 1894, a gateway arch, and Colonial-style rest house designed by W.H. Floyd, of Terre Haute. An estimated 30,000 people have been laid to rest at the cemetery. Highland Lawn Cemetery was listed in the National Register of Historic Places on November 29, 1990.

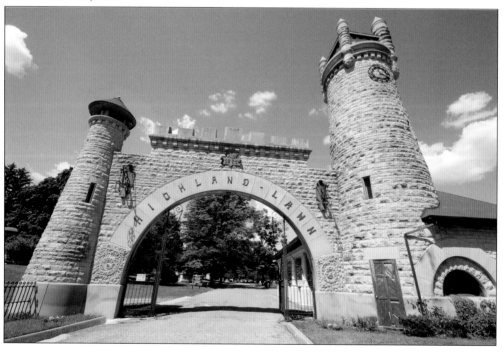

The gravesite of Samantha McPherson, the first person to be interred at Highland Lawn Cemetery, is pictured here. McPherson died of typhoid fever at the age of 30 and was buried on October 29, 1884.

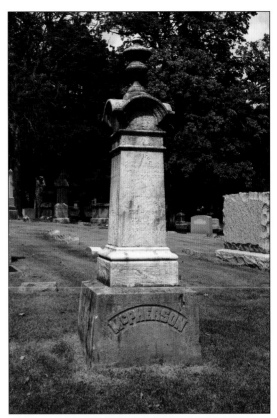

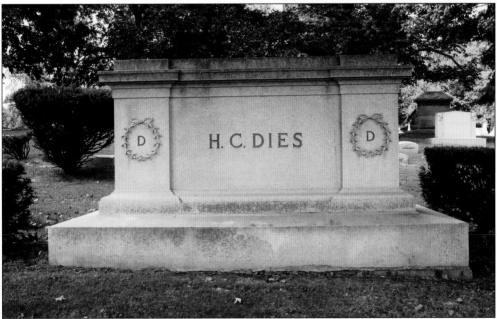

The marker for Henry C. Dies is an eerie welcome after passing through the front gate of Highland Lawn Cemetery. Dies was treasurer of the Clinton Paving Brick Co. and is buried with his wife, Mary A. Dies. Henry and Mary passed away in 1929 and 1957, respectively.

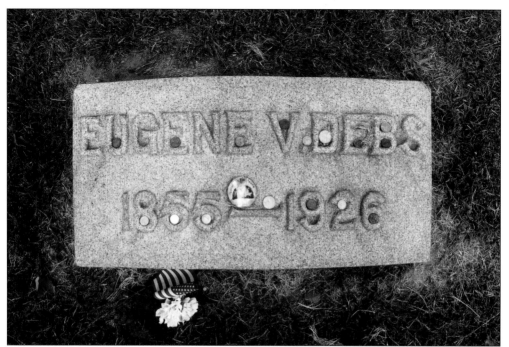

Buried alongside one another in Section One of Highland Lawn Cemetery are Eugene and Kate Debs. Eugene and Kate were married on June 9, 1885. Their Terre Haute residence, known today as the Eugene V. Debs House, was declared a National Historic Landmark in 1966. Eugene is perhaps the most well-known Socialist in the history of the United States. Though society of the times disallowed Kate to campaign for her husband, she stood by Eugene and shared his political beliefs.

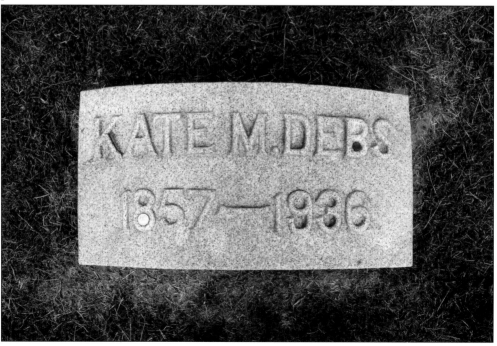

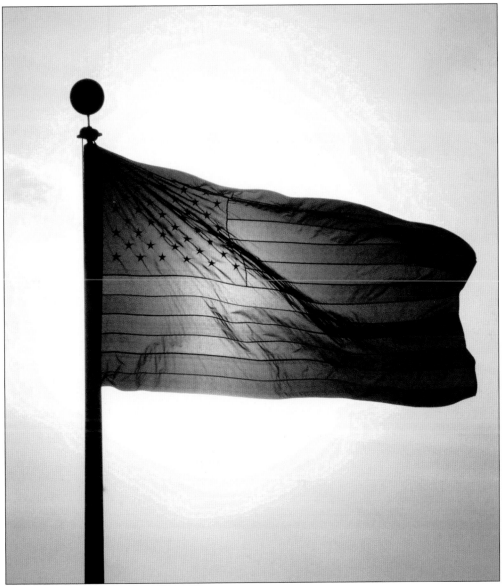

The American flag waves in the wind as the sun sets in the west. This black-and-white image was taken along Indiana 40 in Plainfield. It is a reminder of the women and men of all races, creeds, and colors who have played a prominent role in the history of Indiana's National Road.

Discover Thousands of Local History Books Featuring Millions of Vintage Images

Arcadia Publishing, the leading local history publisher in the United States, is committed to making history accessible and meaningful through publishing books that celebrate and preserve the heritage of America's people and places.

Find more books like this at
www.arcadiapublishing.com

Search for your hometown history, your old stomping grounds, and even your favorite sports team.